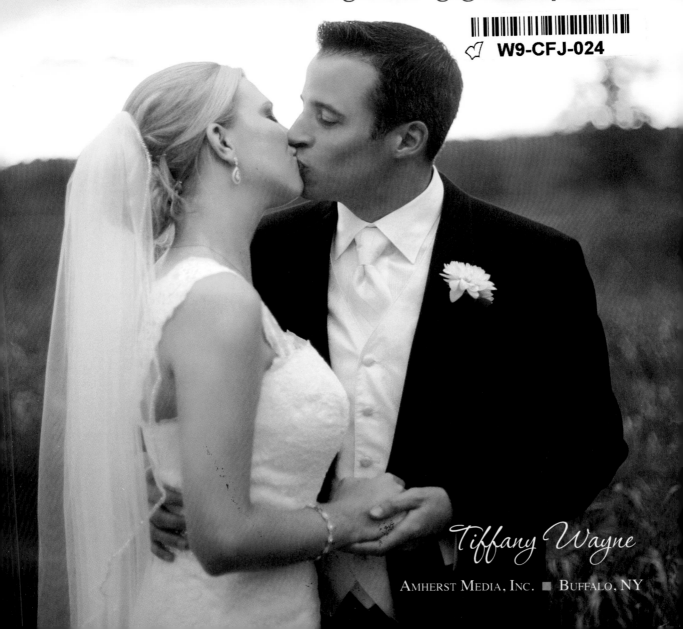

Photograph COUPLES

How to create romantic wedding and engagement portraits

W9-CFJ-024

Tiffany Wayne

AMHERST MEDIA, INC. ■ BUFFALO, NY

About the Author

Tiffany Wayne has always loved taking pictures. She earned a bachelor's degree in Communications from SUNY Cortland. Then deciding on a career in photography she attended Hallmark Institute of Photography in Massachusetts, graduating in 2005 in the top 10 percent of her class. She has since immersed herself in the world of photography directing and styling photo shoots for national publications in both New York City and Los Angeles.

In 2010, she opened her own business working with award-winning musicians, actors, and on-air personalities. She has been featured in *Rangefinder Magazine*, popular wedding blogs, and other magazines. She has also received five honorable mentions from International Photography Awards (Lucie Awards). She enjoys sharing her knowledge and has taught classes for photographers at high school, college, and professional levels. Recently, she has created a scholarship for students pursuing a career in the art field at www.dollarsforscholars.org.

Copyright © 2014 by Tiffany Wayne.
All rights reserved.
All photographs by the author unless otherwise noted.

Published by:
Amherst Media, Inc.
P.O. Box 586
Buffalo, N.Y. 14226
Fax: 716-874-4508
www.AmherstMedia.com

Publisher: Craig Alesse
Associate Publisher: Kate Neaverth
Senior Editor/Production Manager: Michelle Perkins
Associate Editor: Barbara A. Lynch-Johnt
Associate Editors: Beth Alesse, Harvey Goldstein
Editorial Assistance from: Sally Jarzab, John S. Loder, Carey Miller
Business Manager: Adam Richards
Warehouse and Fulfillment Manager: Roger Singo

ISBN-13: 978-1-60895-743-9
Library of Congress Control Number: 2014933310
Printed in The United States of America.
10 9 8 7 6 5 4 3 2 1

Check out Amherst Media's blogs at: http://portrait-photographer.blogspot.com/
http://weddingphotographer-amherstmedia.blogspot.com/

Table of Contents

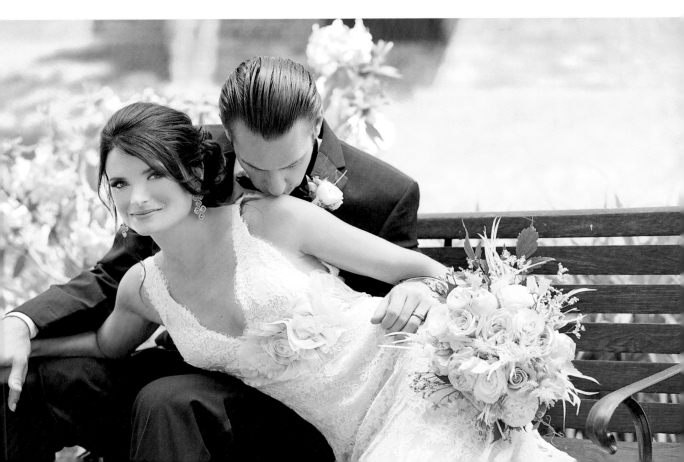

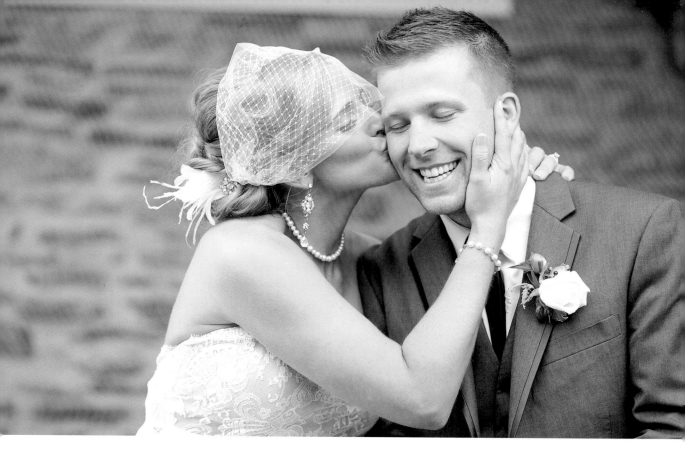

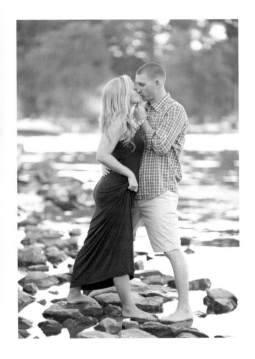

I am so excited to invite you into my world that is known as Tiffany Wayne Photography, a.k.a "TWP!" For me, photography has always been a fun and exciting way to document moments in time from hanging out with friends and family to witnessing couples say "I do," photographs can provide you with memories you will cherish for a lifetime. In this book I hope to inspire those who share the same passion: photographing couples in love. From engagement shoots to weddings, this book will offer fun and useful ideas no matter what your skill level. Most importantly, remember to always have fun and keep smiling!

—*Tiffany Wayne*

Website: www.Tiffanywayne.com
Twitter: @TiffanyPhotog
Instagram: TiffanyWayne

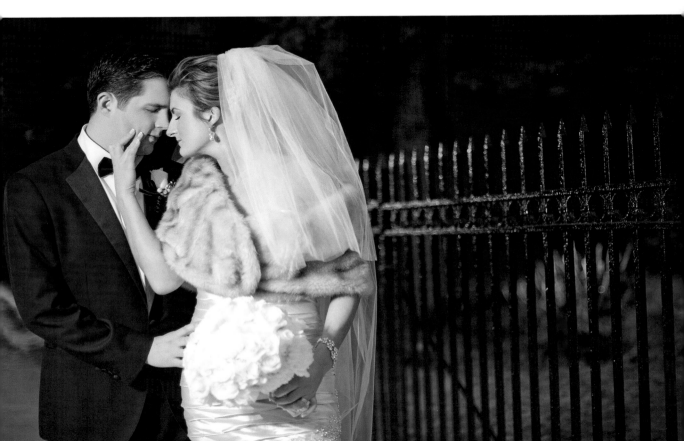

Themes and Props

Engagement portraits do not have to be stiff, mundane, or boring. I like to offer my clients suggestions as to how I might best photograph

I wanted the image to be playful and show their fun side.

them, showing them involved in an activity that they like to share. I always talk with my clients before engagement sessions to find out more about them; I want to make sure that I am representing them in the best way possible.

This engagement session had a picnic theme. We set up a blanket and used several different props, including wine. Props for an activity can inspire a response in your subjects, a response that is encouraged even though the activity is not really happening. Props do that kind of thing to everyone, not just actors! Props also help to define the theme. Because this couple was having so much fun together, I wanted the image to be playful and show their fun side; I wanted to capture them as they really are.

Composition

I thought the image would look really cute if I photographed directly over them. Placing them on opposite sides of the blanket and turning their faces toward each other helped to illustrate the playfulness I was striving to capture.

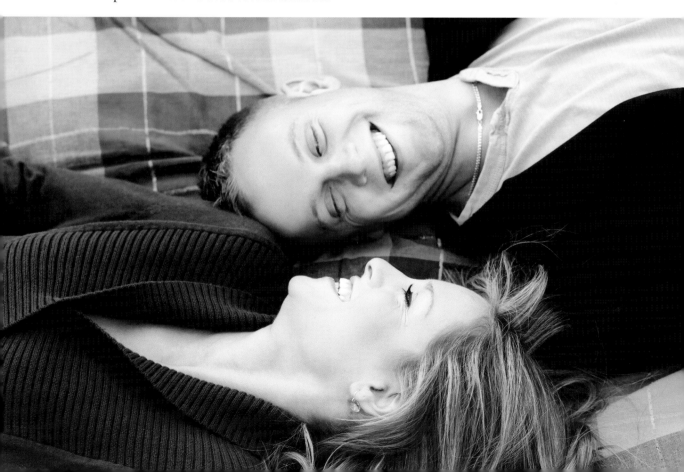

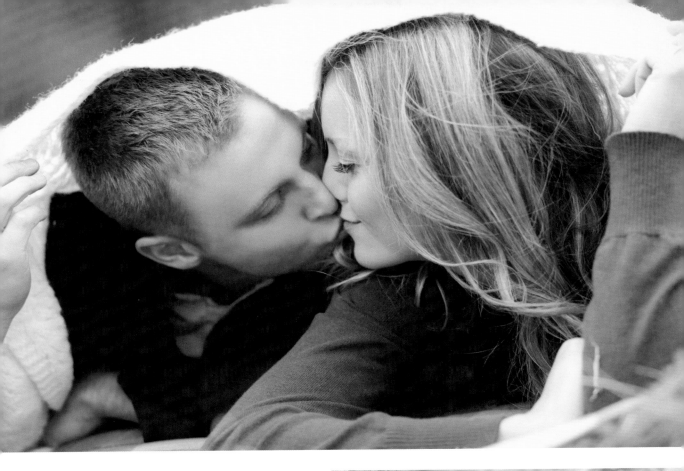

Exposure

I used a Canon 5D Mark II with an 85mm lens at $1/200$ second and ISO 320. I set my f-stop to f/4.5 to ensure that both of their faces would be in focus as I leaned almost directly over them to make the exposure.

In the photo where they are snuggled under the blanket and their lips gently meet, using the same equipment, I changed the shutter speed to $1/80$ second and my f/stop to f/2.8, keeping the ISO the same.

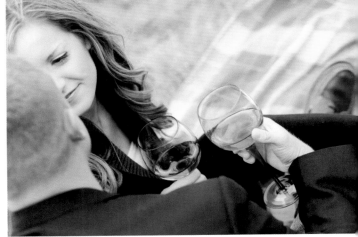

The final image of them gazing into each other's eyes, holding the wine glasses, had an ISO of 800, the shutter speed was $1/160$ second, and my aperture was set at f/3.5.

Doorways for Versatile Framing

Doorways can be so much fun to work with because they have a lot to offer for composition. As squares and rectangles, doors can be used to frame your subjects. Doors and doorways can also provide leading lines to direct the viewer's eye to the subjects. Putting the straight lines of doorways at an angle creates exciting diagonals.

Doorways are found just about everywhere. Our world is full of doorways; be sure to use them to frame your engaged couples and create interesting compositions.

Props Can Inspire!

Encourage your subjects to bring their own props; this will make the portrait even more meaningful to them. The props that you bring might make a very nice photograph; however, using the couple's own props in their portraits will evoke more emotions when they later view the portrait on their wall or in their album.

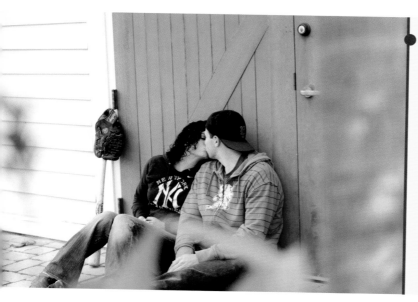

An Alternative Angle

I shot from a low angle and to the right because I wanted it to appear as if my camera caught them when no one was watching. I went to their right and lowered myself so that part of a nearby tree was in the foreground and some of the building could be seen on the right side. Not only does this give the appearance that I *sneaked up* on their kiss, but it also creates depth. Alternative angles allow the viewer to see the subjects from a different point of view. My camera and exposure information remained the same as in the first photograph (facing page).

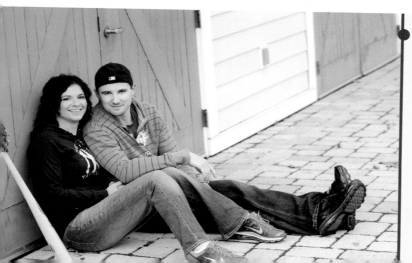

A Pose with A Diagonal Line

The third image is a more traditional pose. I like the diagonal line that moves through the image from the lower left to the upper right, where the ground meets the building. The camera information remained the same, except that my f/stop changed from f/3.2 to f/3.5.

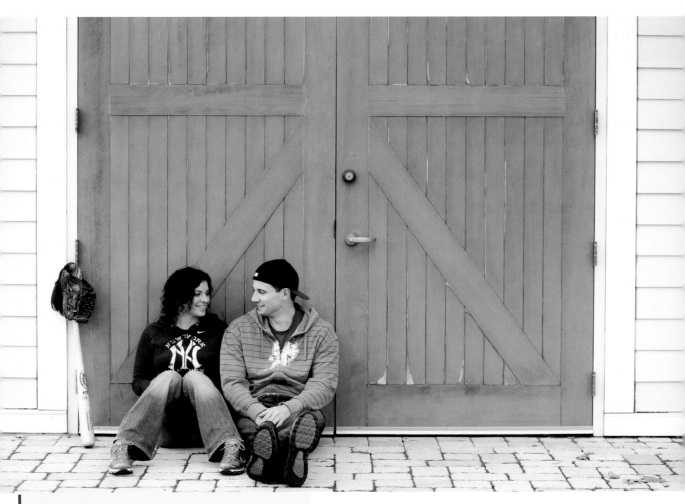

Rule of Thirds and Props!

In this image, I wanted to frame my couple within the square shape of the doorway. The composition followed the rule of thirds with their placement in the lower left third of the portrait.

I liked the contrast of their clothing against the light wooden doors, and I knew that the viewer's eye would be drawn to the couple. Because of their casual attire and setting, I chose a pose that was casual in nature, simply sitting down and "hanging out". This couple has a great love for sports and I loved that they brought their own props—the bat and glove resting next to them was a perfect touch. The image appears very realistic, as if they had just finished playing baseball or softball.

This image was created with a Canon 5D Mark II with an 85mm lens set at f/3.2, $\frac{1}{125}$ second and ISO160.

This couple has a great love for sports and I loved that they brought their own props—the bat and glove.

Environmental Backdrops

Most photographers, when given the opportunity, love to shoot near a lake or ocean. This session took place on a hot summer day in June at Saratoga Lake. Capturing this couple near water was important to them because the groom-to-be proposed to his lovely lady on this dock. I really love incorporating a meaningful location when shooting.

We began the session in downtown Saratoga Springs saving the lake scene for last. I wanted to get the perfect light for such the special location The sun was setting, and the light started to become really warm and beautiful. I knew it was

time to get near the water! We did a few poses to showcase the dock and boats in the background. Ultimately, I wanted to get the couple standing on some of the rocks to share a kiss. Mission accomplished! I just love the romance portrayed in the image!

Equipment and Settings

The facing-page image was created with a Canon 5D Mark II and an 85mm lens. My camera was set at f/2.2, 1/100 second, and ISO 500.

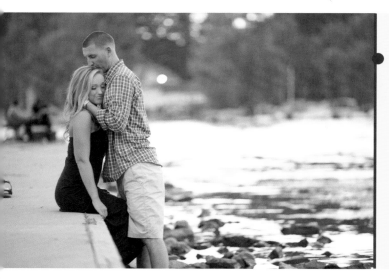

Posing: Romantic Yet Relaxed

I enjoy being at the water with friends and have observed them in many natural poses. I have seen them sit on the dock and put their feet in the water as their significant other approaches and kisses them. I thought this pose would be the perfect and most natural pose to photograph here.

As he kissed the top of her head, I asked her to turn her face slightly toward to camera to see her happy and relaxed expression. This image was shot with my Canon 5D Mark II and an 85mm lens. My camera was set at f/2, 1/100 second, and ISO 500.

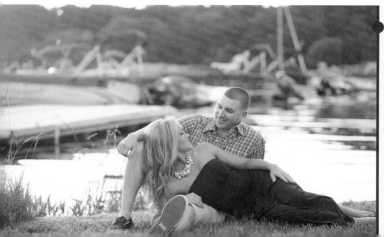

Creating a Frame

Another way to show off a location is by placing it in a distant background from the posed subjects. By doing so you can see more of the environment. In this scenario, the dock and boats created a nice frame around the subjects leading the viewer's eyes right to the couple.

This image was shot with my Canon 5D Mark II and an 85mm lens. My camera was set at f/2.5, 1/800 second, and ISO 500.

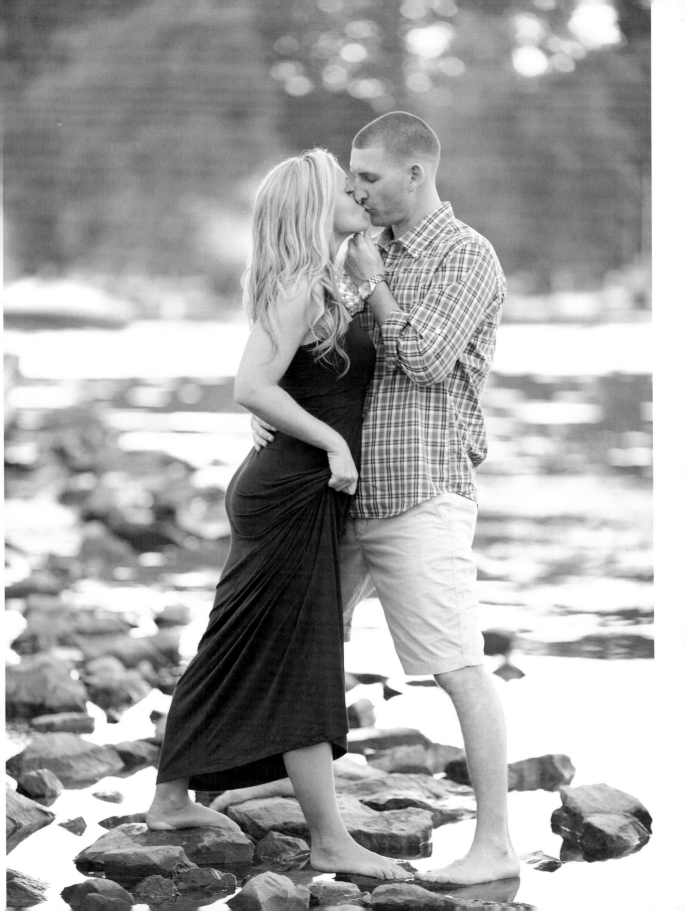

Utilize Windows for Lighting

These two images were created in a hotel lobby in the middle of winter. We decided to start inside in hopes that the wind would calm down before we braved the cold for some outdoor shots. I loved how the lobby was decorated like a home, which gave it a very warm feeling.

Posing

The nearby window gave me beautiful directional light to work with. I placed the groom-to-be directly in front of the window and I had his bride-to-be lean up against him. I wanted them to appear relaxed as they snuggled into each other on this cold winter day.

Positioned in the Light

The positioning of the couple put his face in a profile pose that was aligned to the incoming window light. Her head was nestled under his chin.

By asking her to turn her face to the side and slightly look over her shoulder, her face became nicely lit. Her hair was bathed in the window light.

Equipment and Settings

The image below, taken in the hotel lobby, was created with a Canon 5D Mark II with an 85mm lens. The exposure was f/4, $1/60$ second, and ISO 400.

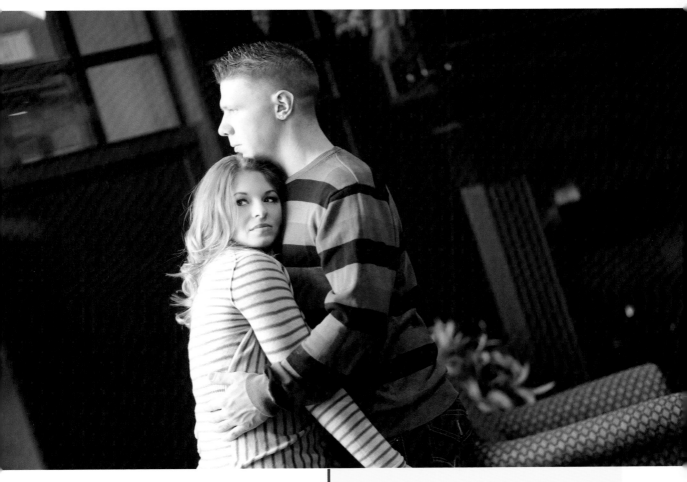

Equipment and Settings

The image above, also taken in the hotel lobby, was created with a Canon 5D Mark II with an 85mm lens. The exposure was f/1.8, 1/80 second, and ISO 500.

The nearby window gave me beautiful directional light to work with.

Save-the-Date

A *save-the-date* announcement is similar to a wedding invitation but is usually sent or is posted before the wedding. It gives people a heads up and lets them make plans for travel, lodging, and care for family members that may not be coming. A save-the-date photograph is an appealing product to offer to the engaged couple. They can use it on their wedding website, social media, mailings, and in their album.

Cold, Snowy Days

This engagement session was held on a very cold winter day; the air was frigid and there was a little snow on the ground. Photographing can be a challenge in the cold. Even though the sky was overcast, the snow reflected the afternoon light. There was ample light for a good exposure.

Letter Props

Every place has local hobby stores to purchase props for the photography sessions. I get can really cool signs, letters—anything you can think of at my favorite store! When I was shopping for props, I saw an entire aisle of letters; I thought this would look really cool if I picked up the first letter to their names. Often times couples like to use an image from their engagement session for their save-the-date announcements, and more often than not, couples use a monogram and/or their initials on part of the announcement or wedding decor. Having this in mind, I thought it would be interesting to include their initials as part of the photograph. Focusing on the detail of the letters gives the couple a lot of creative flexibility with save-the-date designs!

Equipment and Settings

This first image, facing page, was created with a Canon 5D Mark II with an 85mm lens. The exposure wast f/4.5, at $1/200$ second, and ISO 100.

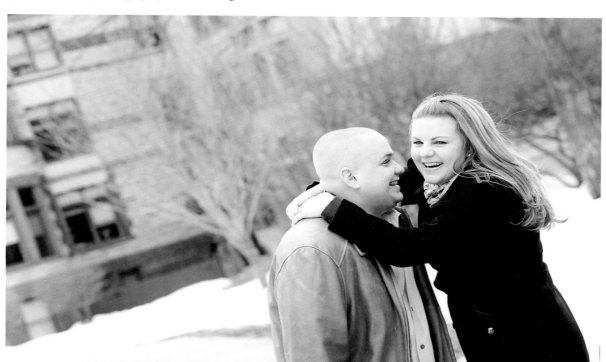

Using Graffiti

Because this couple chose an urban location, I wanted to show some graffiti that was on a nearby brick wall to assist that theme. By having them stand next to the wall, I was able to capture the painting, yet still maintain the focus on the couple.

Using the same camera and lens as the photograph above, I changed my exposure to f/5, at ¹/250 second, and ISO 100. The exposure of the photograph to the left, with the couple laughing and playing in the park, was f/4.5, ¹/200 second, and ISO 100.

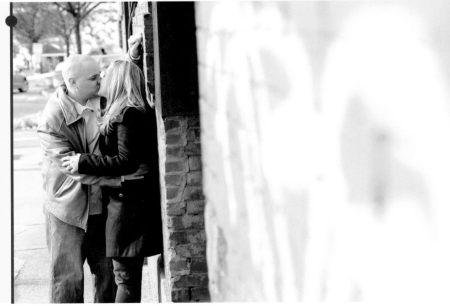

Props Make Meaningful Connections

Displaying Meaningful Props

This is one of my favorite engagement portrait sessions. They came prepared with so many props that were special and sentimental to them; I love when I can incorporate things that are meaningful to a couple. It takes the entire session and each portrait to a new level. Because they had a myriad of items, I felt that the best way to display them all was for them to have a picnic in the park. Their props included antique cameras, books, a few cookies, a picnic basket, and a quilt.

Posing with Props

The day was overcast, which provided great light for the session. I placed the props off to the side for this particular photograph because I wanted the viewer to focus on the pose and their love.

The emotion was evident as he reached up and grabbed his fiancé's hand and rested his head on her arm. Bringing together things that are significant ensures that the photograph will become a cherished treasure.

Lifestyle Poses

In keeping with the picnic theme, I wanted to create more of a lifestyle pose. I picked up a dandelion and placed it in her hand, as if her fiancé had just picked it for her, as she casually reads *Gone with the Wind*. I set my 24–105mm lens at 55mm. My exposure was f/4.5, 1/200 second, and ISO 100.

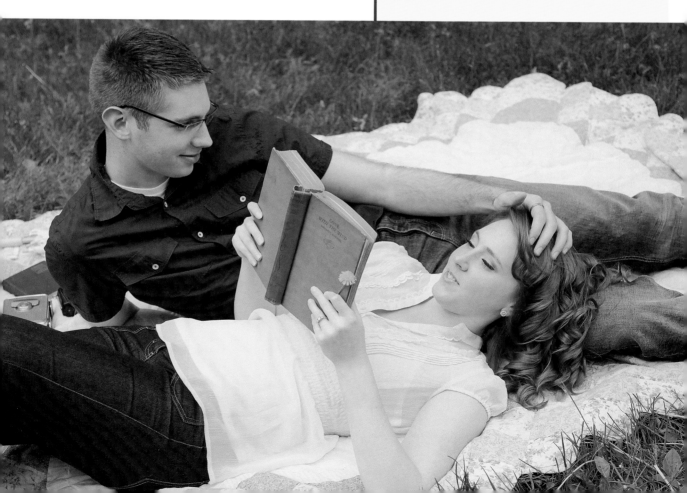

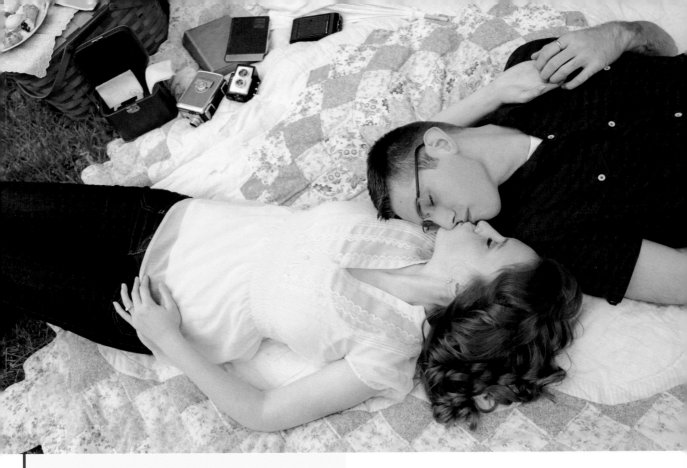

Beauty and Grace

At first I was unsure as to which lens to use, but I decided on the 24–105mm set at 28mm. The exposure was f/4.5, at $1/250$ second, and ISO 100. This was the best choice because of the range of focal lengths. This photograph speaks to me of beauty and grace.

I love when I can incorporate things that are meaningful to a couple.

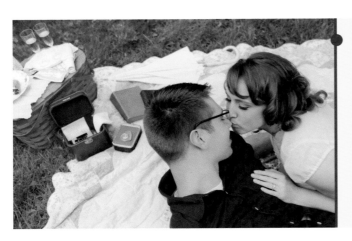

Cropping Can Enhance

I intentionally cropped this image so that the viewer can see the surrounding environment, including the vintage camera, the picnic basket, the two wine glasses, and a glimpse of the food. I love how a simple kiss on the nose can translate to warm, fuzzy feelings. Using the same lens as with the other two images from this session, I set it at 35mm at f/4.5, $1/250$ second and an ISO of 100.

Backgrounds and Location

I flew out to California for this engagement session and was thrilled to have different scenery to add to my portfolio. We planned on photographing at two different locations, and our first stop was the beach; I wanted to make sure that I captured the palm trees in this image to show that the subjects were not in New York.

It is important to include enough of the background to tell the viewer where the couple is located.

When photographing environmental portraits, it is important to include enough of the background to tell the viewer where the couple is located: city, country, beach, tropics, or on a snowy mountain. By lowering my position and photographing at an upward angle I ensured that the viewer can see the beach environment (facing page).

My Goal

My goal with this session was to create a look as if the images were taken with an old Polaroid camera; to help achieve this impression, I wanted the image to be slightly overexposed. By overexposing the image and by adding a filter in post-production, I knew that I would achieve the look I was seeking.

Equipment and Settings

Using my Canon 5D Mark II, I set the 24–105mm lens at 60mm. My exposure was f/4, 1/500 second, and ISO 125.

Overexposing for Effect

These images are even more overexposed than the photograph of them sitting on the beach (facing page). Again, this was created intentionally for the desired look; the image as a whole reminds me of a painting.

Overexposed images will wash out the background. In this case, only the palm trees came through from the background, like symbols that tell the viewer where this couple had the photo taken—a tropical beach! This is overexposing with a purpose.

For the left image, the lens was set at 55mm. The exposure was at f/4, 1/640 second, and ISO 400. My exposure for the right-hand image, using the same camera equipment (lens set at 40mm) was f/4, 1/80 second, and ISO 400.

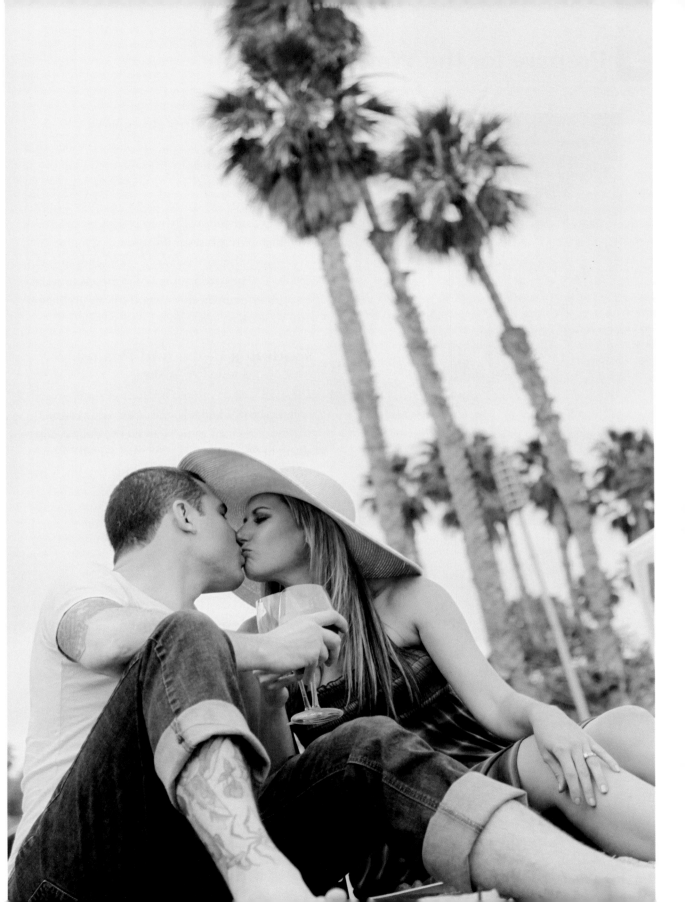

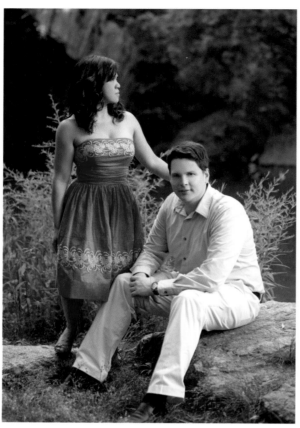

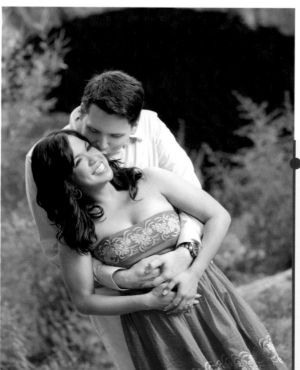

Future Wedding Sessions

Engagement sessions give the photographer an opportunity to study their clients; they can observe how they interact, their sense of humor, and how they show affection. Knowing these things can help tremendously when photographing their wedding. While interactions, sense of humor, and everything else may vary, the one common theme is *LOVE*. They are a source of joy to each other. As a photographer, it is my job to capture that joy and show them what their love looks like.

Finding a Place and Posing

This session was in Central Park in New York City. We walked around and found some great, secluded paths and a large rock that was sitting next to a body of water. I asked the young lady to sit on her boyfriend's lap because I really wanted to focus on her expression and the happiness he brings to her life. With her arm slung around his neck and wearing a big smile on her face, she gave me what I needed.

Equipment and Exposure

All three images were photographed with a Canon 5D Mark II, with my 24–105mm lens at 85mm. The exposure for the three photographs: f/2.8, $1/200$ second, and ISO 200.

Minimize Height Differences, Part 1

wanted to include a variety of poses in this location. I felt that having him sit on the rock while she stood would be a nice pose (top); this way, the viewer would not focus on their height difference. I asked him to lean forward on his elbows because typically, this will allow the subject to appear more relaxed.

Height Differences and Posing, Part 2

For the next image (bottom), I instructed him to lean toward his fiancé for a kiss. Again, this takes the focus off how much taller he is than her.

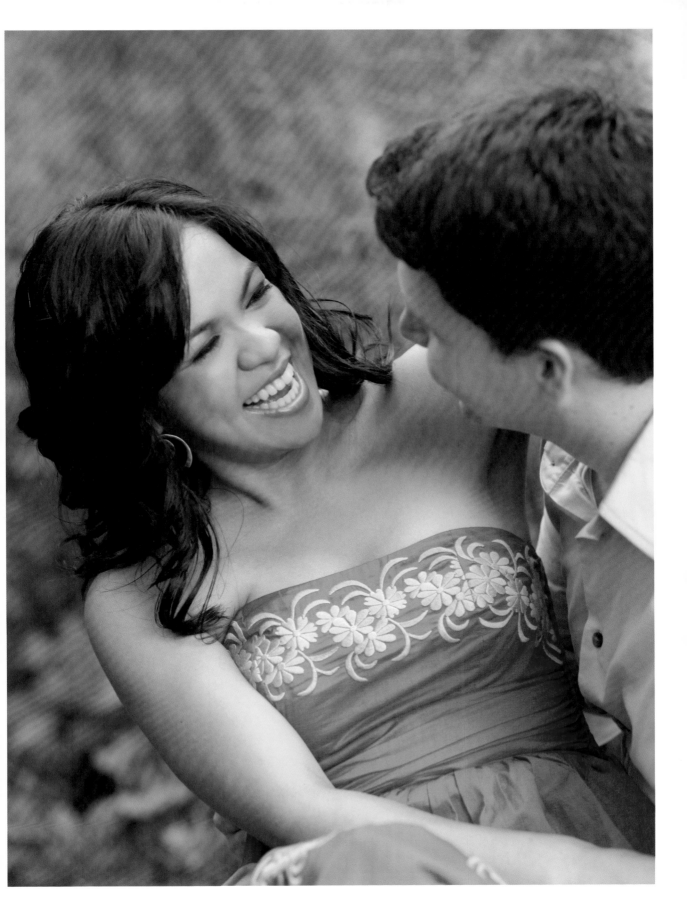

About Lifestyle Sessions

I like to chat with my clients to learn more about them as a couple before I begin an engagement session. Knowing what types of things they like to do can help me showcase them in the most natural way possible. I love documenting couples in a lifestyle setting, almost as if I am a part of the paparazzi and they are the famous Hollywood couple everyone is talking about. There is something very real about photographing in a lifestyle manner; I enjoy working that way because my clients can relate to it and it becomes an adventure, as well as fun, for them.

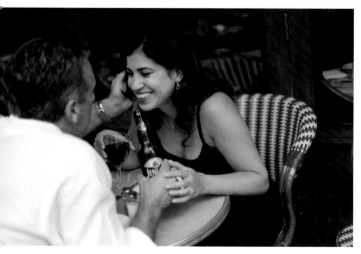

Posing in a Restaurant

This particular session in New York City gave me the perfect opportunity to photograph in a lifestyle manner because they wanted to go to their favorite restaurant. Posing in a restaurant is not normal, nor is it easy; I wanted to re-create the scene as if they were there simply enjoying each other's company on a regular night out. I felt that photographing them outside on the patio would look really cool because of the way the lights were shining through the window. In addition, by being outside of the restaurant, we would not be interrupting any of the other guests. Placing the table in front of the couple helps show the environment, and by placing them slightly off to the side, created that real *lifestyle* moment I was trying to achieve.

Lifestyle Theme Environments

Lifestyle sessions can be photographed in restaurants, as we show here, as well as parks, sporting events, shopping, picnicking and a variety of other everyday activities. Be sure to include environmental aspects such as furniture, lights, and architectural details, which can help define the subjects within the location, helping to communicate the lifestyle.

Equipment and Settings

All three of these images were photographed with a Canon 5D Mark II and the 24–105mm lens was set at 50mm. The image, right, was taken at f/1.8, 1/400 second, with an ISO of 640. The second photograph, top left, was also taken at f/1.8, but the shutter speed was 1/50 second and the ISO was 200. The third image, bottom left, was shot at f/1.8, 1/50 second, and ISO 250.

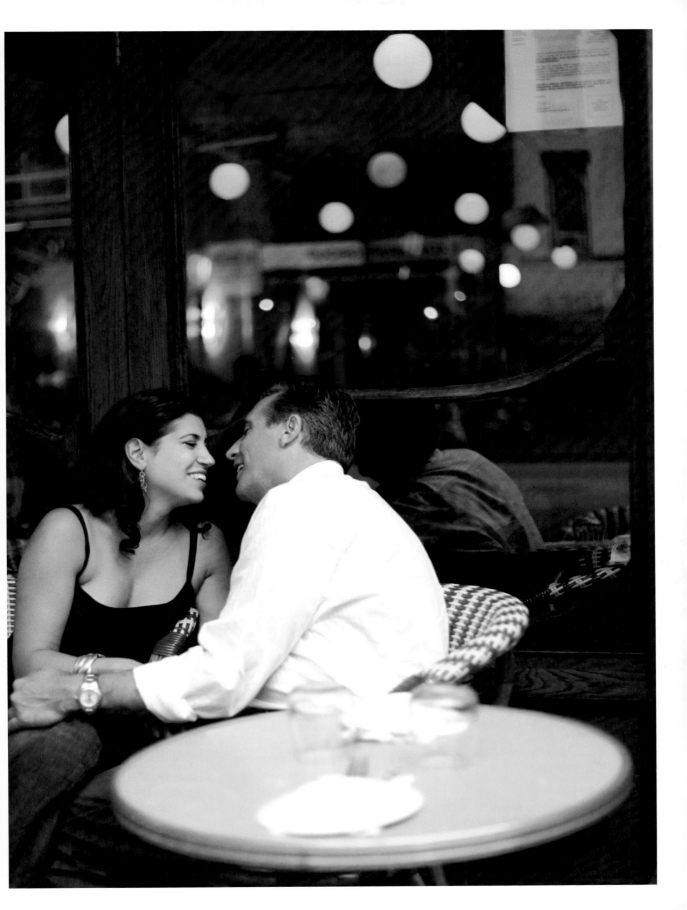

Local Settings

The Historic Barns of Nipmoose is one of the most beautiful country barn settings in my local area; it is no wonder that my clients want to be photographed there. As the golden light sets behind the hills, it lights up this location in ways I have never seen before.

Explore Location Options

The way the light hits the barn accentuates the textures of the wood, making this scene (facing page) look like a painting. For this photograph, I asked my couple to hold hands and walk away from me. As they walked toward one of the barns, I captured this moment. The colors in their clothing complement the scenery well, and I love that it looks like they are walking off into the sunset together.

Explore the location for interesting textures, patterns, shapes, lines, shadows, furniture, and lighting options. Some locations are unexpectedly rich in these elements; other locations have options that may not be immediately apparent and will need a discerning eye to draw out the opportunities that are present. If possible, scout the location at different times of the day. There can be dramatic differences in how the light illuminates your subjects as it changes source or direction.

Equipment and Settings

All of these images were photographed with a Canon 5D Mark II and the 24–105mm lens was set at 85mm. They were all taken at f/2.5, with an ISO of 250. The only difference was the shutter speed; images on the facing page were photographed at $1/400$ second, while the image below was photographed at $1/250$ second.

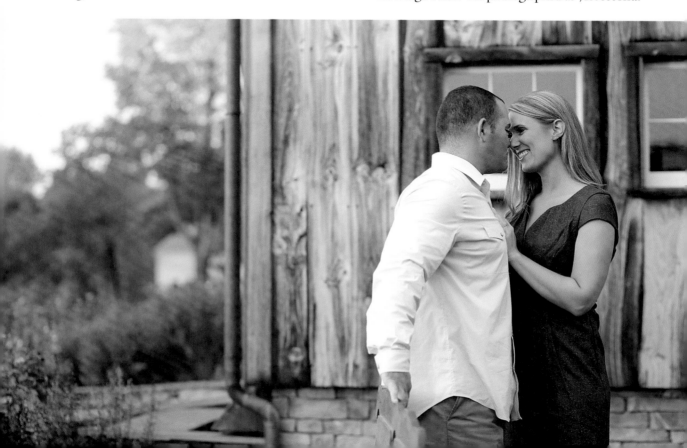

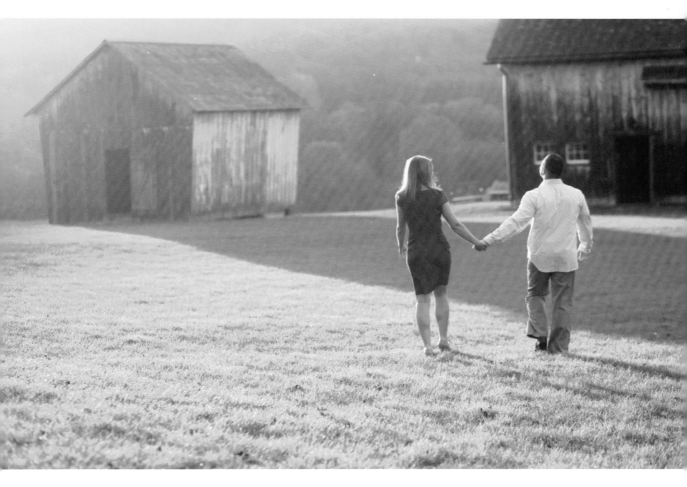

Proper Positioning

For this image, we pulled out a bench that was inside one of the barns and placed it next to the barn and plants. I positioned myself in a way so that their bodies were centered in the negative space next to the barn. I like how the sky splits off from the barn, keeping the viewer's eye on the couple, and blurring out the plants in the lower left foreground helped create depth.

Background Indicates Season

I photographed this couple in the winter in downtown Albany and I wanted it to be obvious that this session took place near the holiday season.

About This Image

I knew of a side street in Albany that was decorated with some white lights; by making the background and the lights blurry, her red jacket would really pop (facing page). I thought the background helped framed them nicely.

This is more of a traditional pose, yet it still gives off a natural feel. Because of their height difference, I asked her to lean into her fiancé and rest her head gently on his chest; this gave me a nice image where both subjects were focused on the camera without doing the "prom pose."

Next, we made our way to a nearby bridge and stairwell (right). I noticed that there was some nice directional light underneath the staircase and decided to use it to my advantage. By placing the couple under the stairs, I was able to create this moody portrait.

Equipment and Settings

All three of the images in this series were photographed with a Canon 5D Mark II, and the 24–105mm lens was set at 85mm. The image on the facing page was taken at f/2.8, 1/200, and ISO 250. The image below was taken at f/2.0, 1/125, and ISO 125. The last image, bottom left, was taken at f/2.8, 1/125, at ISO 250.

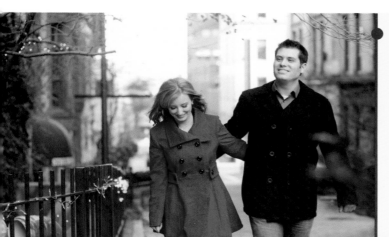

Photograph a Range of Emotions

Everything in a photograph contributes to the emotion that is expressed. Look at the differences in these three images: traditional (love), candid (joy and happiness), and posed (comfortable). It is important to know what the couple wants to communicate, and then photograph for a range of emotions and moods.

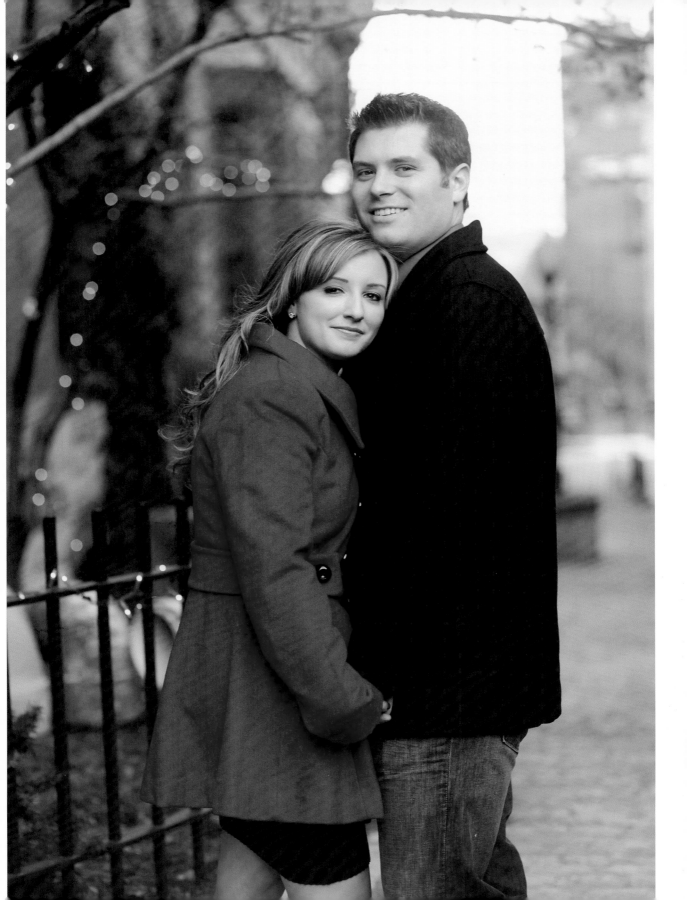

Include Their Pets

The couples that I photograph often want to include their dogs in their engagement session. Being a dog owner, I know how easily pets become a big part of your life. When photographing dogs with a couple, it always helps to have the dog's fa-

I am a big fan of using selective focus when photographing my clients with their pets.

vorite treats with you; this way, you can get the dog's attention for the photograph.

I am a big fan of using selective focus when photographing my clients with their pets. I like to switch back and forth from focusing on the animal, usually dogs, and focusing on the couple. At this particular location, I found a teal wall which I thought would be a nice solid background because I was planning on cropping very tightly; I wanted the focus to be on their pet with them kissing in the background.

Equipment and Settings

All three of the images in this series were photographed with a Canon 5D Mark II, and the 24–105mm lens was set at 85mm. They were all taken at f/2.2 with an ISO of 100. The only thing that changed was the shutter speed: the image on the facing page was shot at 1/800 second; the image above was shot at 1/400; and the image left was shot at 1/500 second.

A Candid Look in a Posed Photograph

After focusing on the dog in the image, I wanted to focus on the couple in the next photograph. I was able to create this "candid" image by asking the bride-to-be to look at the camera, while her fiancé looked at her lovingly.

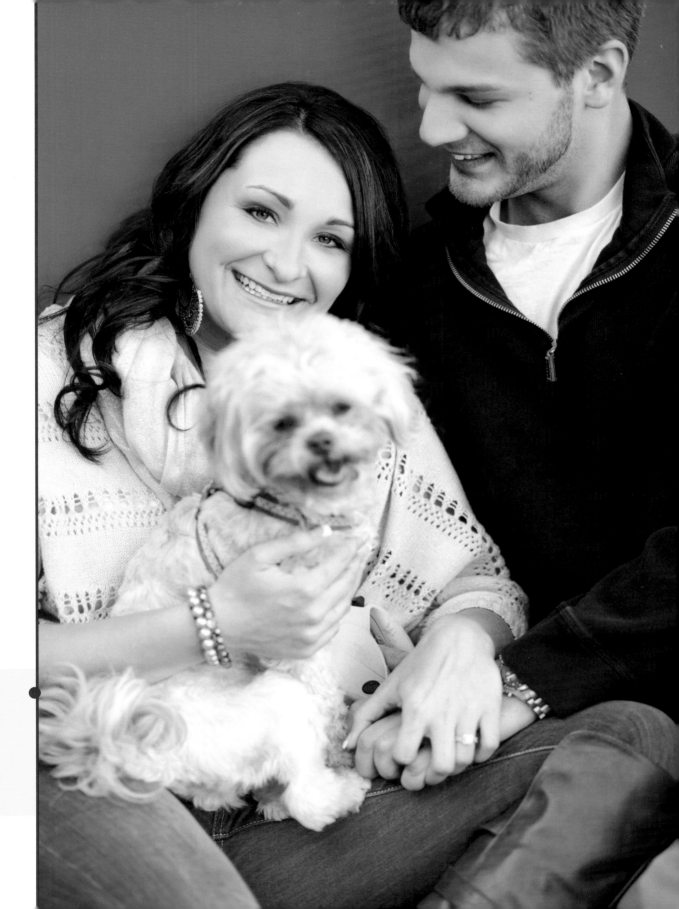

Inspiration from Print Ads

Behind this couple's favorite restaurant was a sidewalk and path along a river. There was an old bridge that sat in the background with lights and rope that lined the pathway. Instantly, I thought of Nautica and JCrew clothing print ads. This inspired me when posing my clients.

I asked them to simply hold hands and walk toward me.

Walking Can Set the Tone

To get my clients warmed up, I asked them to simply hold hands and walk toward me. This exercise helps the couple become acclimated to having a camera in their faces, all while doing something they do not have to think about—walking. I particularly love casual walking photographs because every couple holds hands at some point when they are walking together, whether it is running errands or going to dinner; it makes the photo real and the viewer can relate. I loved seeing the joy in both of their faces in these photographs.

Use Your Location to Create a Frame Around Your Subject

I loved framing this couple with the rope and posts. By showing part of the rope in the foreground it helped create a half-circle around the couple and brings the viewer's attention right to them.

Equipment and Settings

All four of the images in this series were photographed with a Canon 5D Mark II, and the 24–105mm lens was set at 85mm. They were all shot at f/2.8 and ISO 400. The only thing that varied was the shutter speed: upper left, then clockwise: $1/400$, $1/1250$, and $1/1000$ second. The image on the facing page was shot at $1/800$ second.

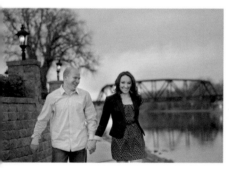

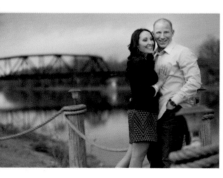

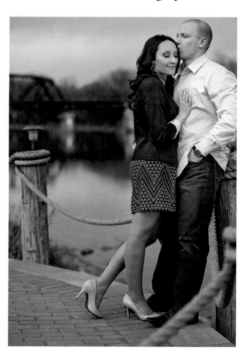

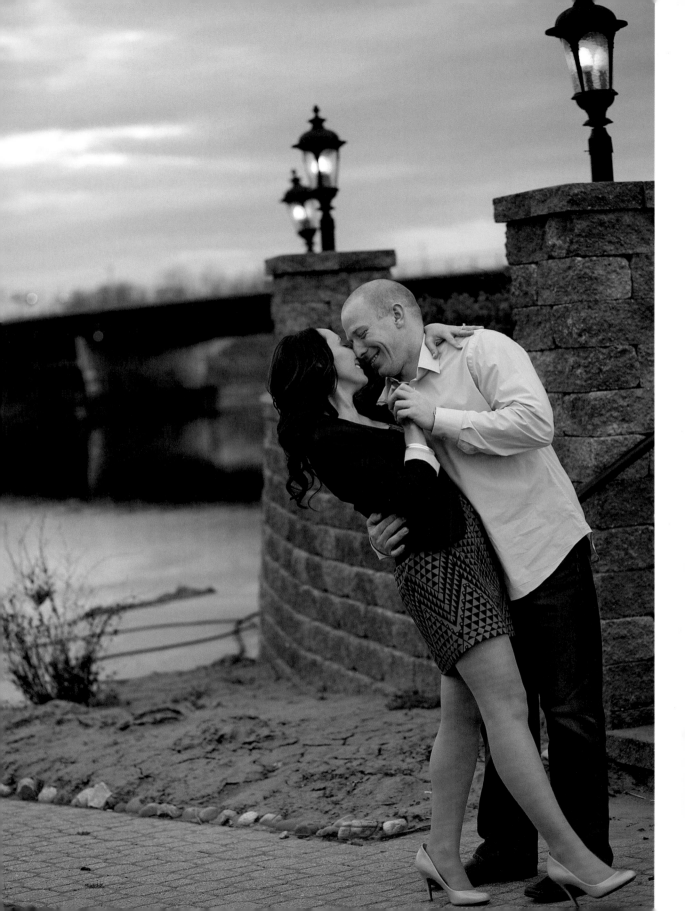

Planning the Background

As we walked around downtown Schenectady, I was immediately drawn to this ivy-covered wall. My thought was that the pastel colors my clients were wearing would look wonderful against the white painted brick with green vines. The sky was

I wanted this session to be playful and fun since that is exactly how I would describe this couple.

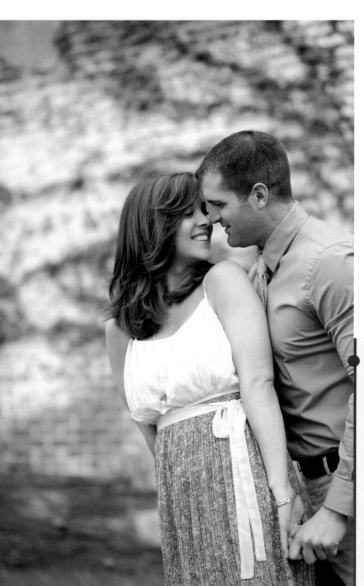

overcast, providing a nice soft light. I wanted this session to be playful and fun since that is exactly how I would describe this couple. I intended to capture their lighthearted feelings in the images by emphasizing their body language and facial expressions.

Equipment and Settings

All three of the images in this series were photographed with a Canon 5D Mark II, and the 24–105mm lens was set at 85mm. They were all taken at f/2.2 and ISO 200. The only thing that changed was the shutter speed; both images (facing page) were shot at $^1/_{200}$ second, and the image left was $^1/_{100}$ second.

Creating a Design Element

The green vines radiating from the upper-right side of the frame spread out as they progress toward the left side of the image. By placing the couple to the right and turning her body toward him, the couple creates a nice design sense between the brick and their pose. The viewer's eyes track upward to the couple's faces, then follows the radiating lines of the vines. The diagonal created by the couple's bodies pulls the viewer's eyes back to their faces, and then the gaze follows the radiating lines. The composition has a design element that is challenging to plan for, but is very pleasing.

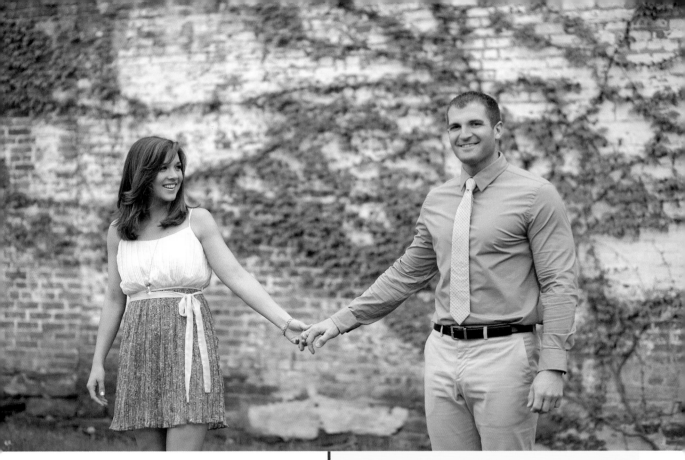

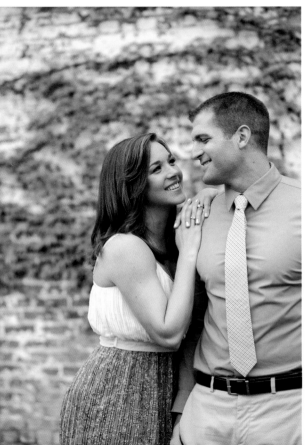

Soft Backgrounds

Because the background was heavily textured, I wanted to make sure that it appeared softer in the final image. So, I set my camera to f/2.2, which created my desired look. The wide aperture allowed more light in and helped to narrow the focal point, in turn creating the soft or blurred background. When photographing at a higher f/stop such as f/8 or f/11, less light is captured in the image and the lens focuses on a greater range of depth, as opposed to a specific area selected by the photographer as was done in this image.

Style, Fashion, and Ediginess

I was able to produce some of my favorite images with this engagement session. Like me, this couple had an appreciation for style and fashion. Prior to the session, the couple told me they wanted to pose with a vintage car, which I thought would be the perfect prop. I wanted a somewhat edgy pose, as if they were being photographed for a luxury magazine. Their outfits, paired with the antique car, fit my vision perfectly.

Equipment and Settings

All three of the images in this series were photographed with a Canon 5D Mark II and a 135mm lens. While the ISO remained at 200 for all three photographs, the upper-right image was photographed at f/2.5, $1/320$ second; the lower-right image was f/2.5, $1/100$ second; and the lower-left image was made at f/2.8, $1/160$ second.

I wanted a somewhat edgy pose, as if they were being photographed for a luxury magazine.

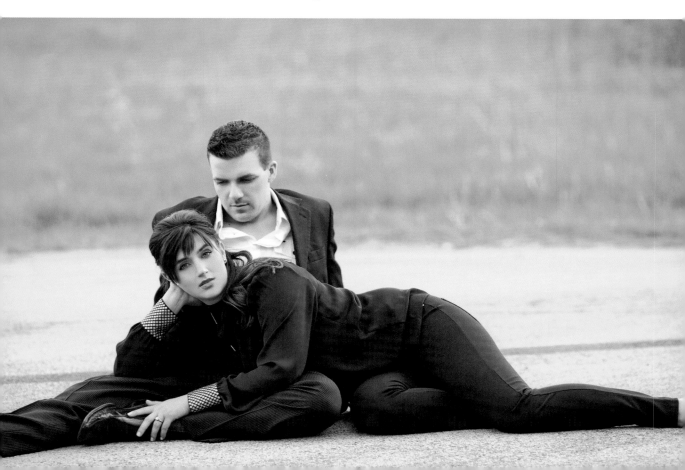

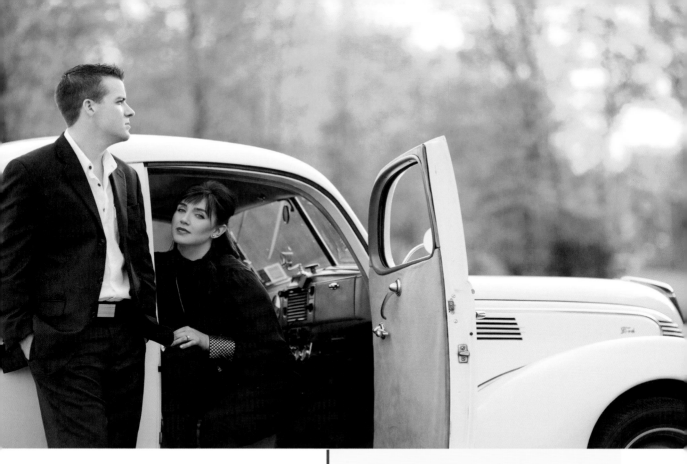

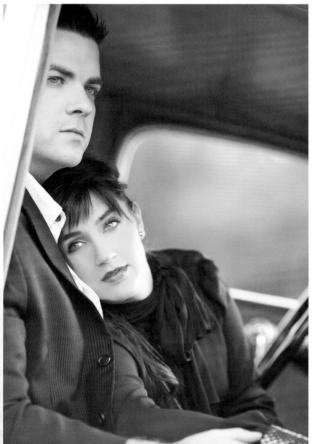

Posing with the Car

I asked them to park the car in front of a row of golden trees; their outfits were black and the car was white thus, the colorful trees really made them stand out (above). I wanted to show some attitude in this image so I opened the car door and had him stand outside, as if he just opened the door for her. I asked her to lean toward him, and by tilting her head slightly in the other direction and stare at the camera, I was able to achieve the edgy look I was after.

Communicating Peace

For this image (left), even though it was early in the day, I began to think about drive-in movie theaters. I posed them in a way to convey that they were simply relaxing in the car, as if waiting for the movie to begin. The diagonals instigate the viewer's eyes to circulate through the image. The negative space created by the window in the background also pulls the eye to the background and allows it to return to the subjects. In spite of the movements the eye makes in viewing this image, a peacefulness in the moment is conveyed.

Using an Open Field

I love photographing in an open field with tall grass; I love it even more when the couple is all dressed up because of the contrast to the location. When I see an open field, it takes me back to being a kid and playing outside. I associate an empty field with having fun! This was my thought process before I created this image.

Playing Around, Having Fun

I wanted the couple to appear as if they were just playing around and having fun. I asked my clients to grab hands and then spin around as if they were dancing. I love the expression on her face as she looks back at the man of her dreams! The light was nice and soft because of the cloudy sky, and by photographing at f/2.8, I was able to keep my focus on the bride-to-be and blur the rest of the frame.

Equipment and Settings

These images were photographed with a Canon 5D Mark II and a 24–105mm lens at 85mm. They were all taken at f/2.8 and ISO 200. The only thing that changed was the shutter speed: this page and the facing page (top), $\frac{1}{320}$ second; facing page (bottom), $\frac{1}{200}$ second.

Emphasizing Her Eyes

This image was created to focus on, and emphasize, my client's amazing blue eyes. I intentionally slightly overexposed this photograph so that the color of her eyes really popped against her fair skin and light hair.

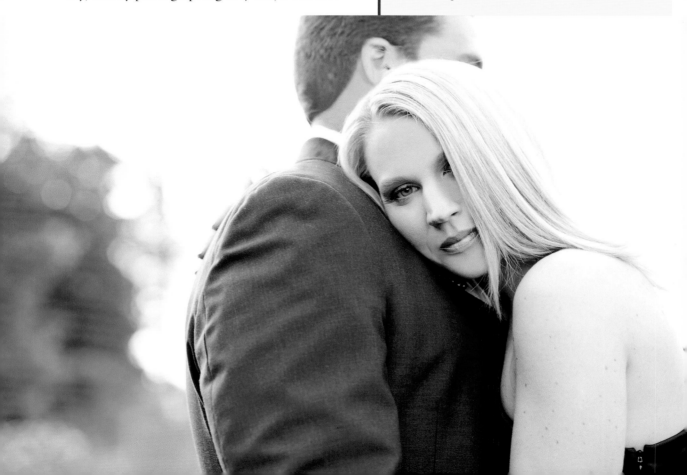

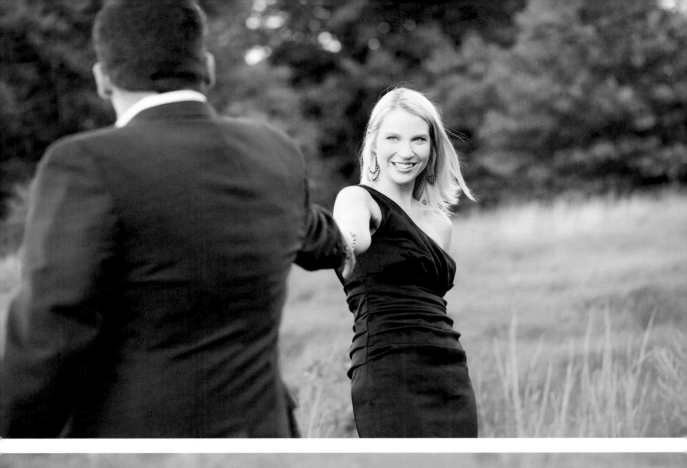
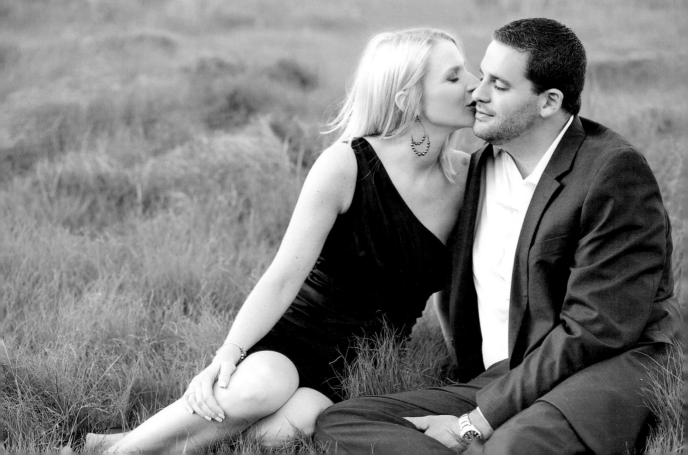

Memories, Emotions, and Love

Memories evoke emotions. The settings used for this session cue the subjects and viewers alike to remember fond memories of school, graduation, friends, and love. A compelling image captured in the right setting can spur memories that in turn trigger emotions.

Leading the Viewer's Eyes

This couple went to high school together and felt that an engagement session at their alma mater would have special meaning. We began the session at the track and field (below) because there were so many areas that would make for an interesting composition. I love it when the surrounding environment can be used in a way that will lead the viewer's eyes to my subjects. Using

the fence at the corner of the image creates a line that brings attention directly to the couple. Extending her arm along the fence makes her body appear more relaxed, and instead of a traditional kiss on the forehead, I asked her to turn her head slightly toward the camera, to ensure that I could see her face.

Keep Your Location Fluid

After we finished photographing at the high school, we went to another location where they spent a lot of time together. This place had horses, and I look forward to any opportunity to pose couples with animals!

We weren't sure t first whether we would be able to get close to the horses, but it did work out. When working with large animals, especially

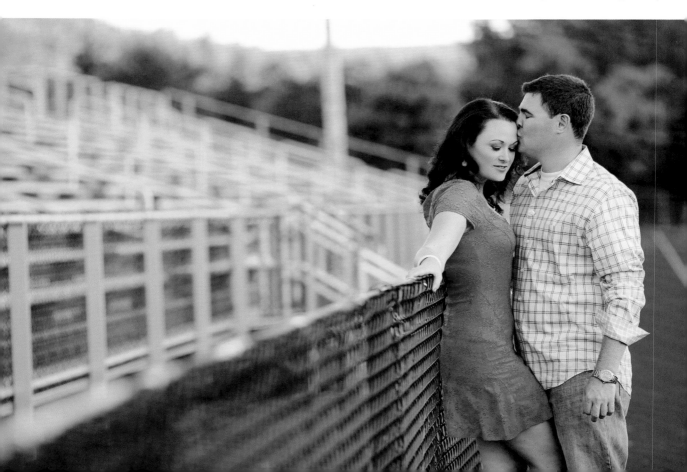

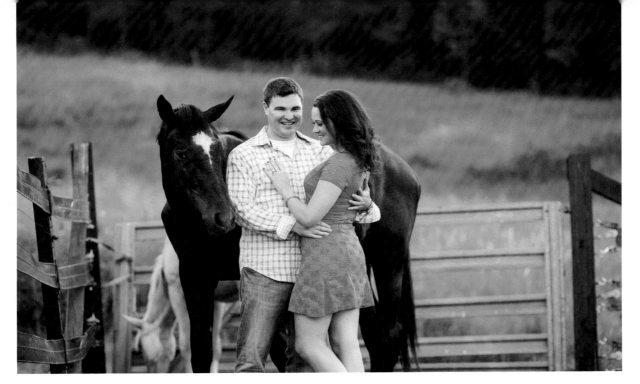

horses, posing is very important because a lot of movement may scare the animal, and we did not want anyone to get hurt. I loved that the horse turned right to the couple the moment they embraced.

Equipment and Settings

All three images in this series were photographed with a Canon 5D Mark II with a fixed 135mm lens. The image at the high school was shot at f/2.8, $^1/_{500}$ second and ISO 400. The image on with the horse was shot at f/2.8, $^1/_{200}$ second with an ISO of 500 and the image with the car was set at f/3.2, $^1/_{500}$ second, and ISO 800.

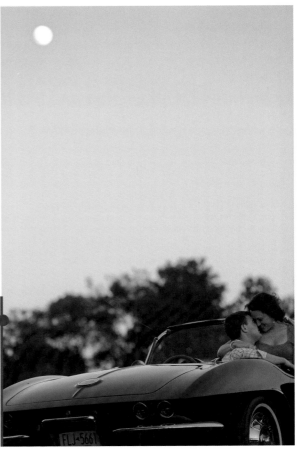

Moon, Car, and Loving Couple

As dusk set in, I wanted to capture the couple in their car as if they had just come back from a high-school football game. The moon was out and I wanted to make sure that it was visible in the photograph. I like how the moon in the upper-left corner of the frame balances the couple in the lower-right corner.

Details Create Interest

This series of photographs took place moments after the couple were married. However, since they were not dressed in traditional wedding attire, I felt that it could easily pass as an engagement session. Detailed photographs are always important to include when photographing engaged couples because they have the potential to speak volumes.

Equipment and Settings

All four images in this series were photographed with a Canon 5D Mark II with a fixed 135mm lens at f/2.8. The ISO was 800. The image on the facing page was photographed at $^1/_{200}$ second, the top and bottom images were shot at $^1/_{1600}$ second and the middle was shot at $^1/_{2000}$ second.

There is always a chance that detail will be lost when using a lens flare effect.

Using Lens Flare for Artistic Effect

The street was lit nicely from the sunset; I thought capturing some images of the couple walking toward the sun would not only look pretty, but would also play into the artistic style they were trying to achieve. By photographing directly into the sun, I was able to get lens flare; lens flare is not always desirable when photographing at sunset, it all depends on the look you are seeking. I felt the flare added to the image and I was very happy with the outcome.

There is always a chance that detail will be lost when using a lens flare effect. If it is consistent with the artistic style you wish to achieve, then it is worth the compromise in detail!

Details and Posing

In this exposure (facing page), I placed the couple in a way where I could focus on his hand and her leg. I wanted to frame some of the wall in the photo because it helps tell the story of the moment we were creating. By asking my client to bend her leg against his, a nice triangular shape of light was created against his dark suit. To tie the image together, I simply asked him to place his hand on her leg, bringing the image to life. Converting this image to black & white brought out a more artistic vibe, which is what I was trying to achieve.

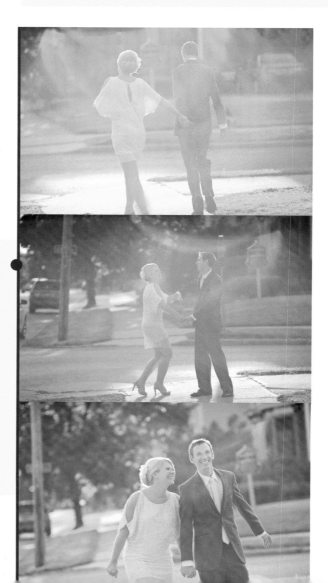

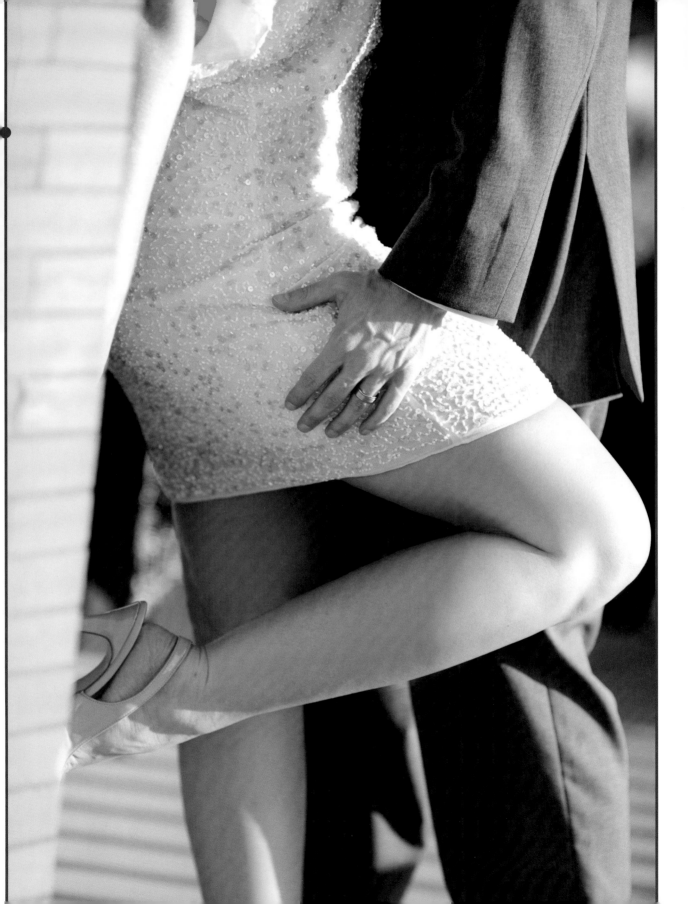

Open Spaces

Open spaces create options for posing. There is a large open area along the Hudson River in downtown Albany that provides a great space for creating photographic images. Using the open space for the background can give a single texture or color to surround your subjects. Depending on your angle, it can also infuse the composition with a variety of leading lines. In any case, open spaces seem to inspire your subjects to move about and interact freely with each other.

Architectural Features In Open Spaces

When shooting the photograph on the facing page, I was perched on a small hill with steps used by the city for free, summer concerts. I knew that I wanted to photograph at a downward angle because I liked the square shape the cement ground

was forming around the couple. The sun lit up the trees in gold, which provided a nice band of yellow at the top of the image, directing the viewer's eyes down toward the couple. I asked them to dance around as if they were attending one of the concerts; while it may feel silly to dance in front of a camera with no music, it was because it was so silly that they were able to give me great smiles. When he pulled his fiancée in close to give her a kiss, I knew this moment was one they would remember for a lifetime.

Equipment and Settings

All three images in this series were photographed with a Canon 5D Mark II with a fixed 135mm lens at f/2.8 and ISO 400. The image on the facing page was photographed at $1/1600$ second, the image on the left was shot at $1/640$ second, and the center image was shot at $1/1250$ second.

Nothing Says Romance Better Than an Almost Kiss

After photographing away from the sun for part of the session, I wanted to create some images where I aimed into the sun. Next to the steps where I was photographing the couple was a small, grassy field where the sun was shining perfectly. Nothing says romance more than the "almost kiss" as the sun sets behind you.

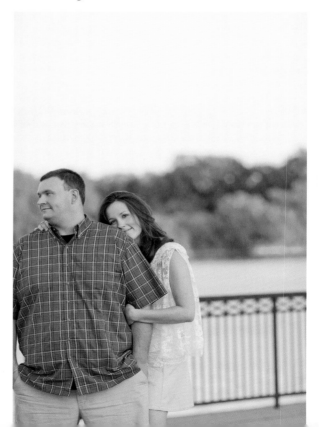

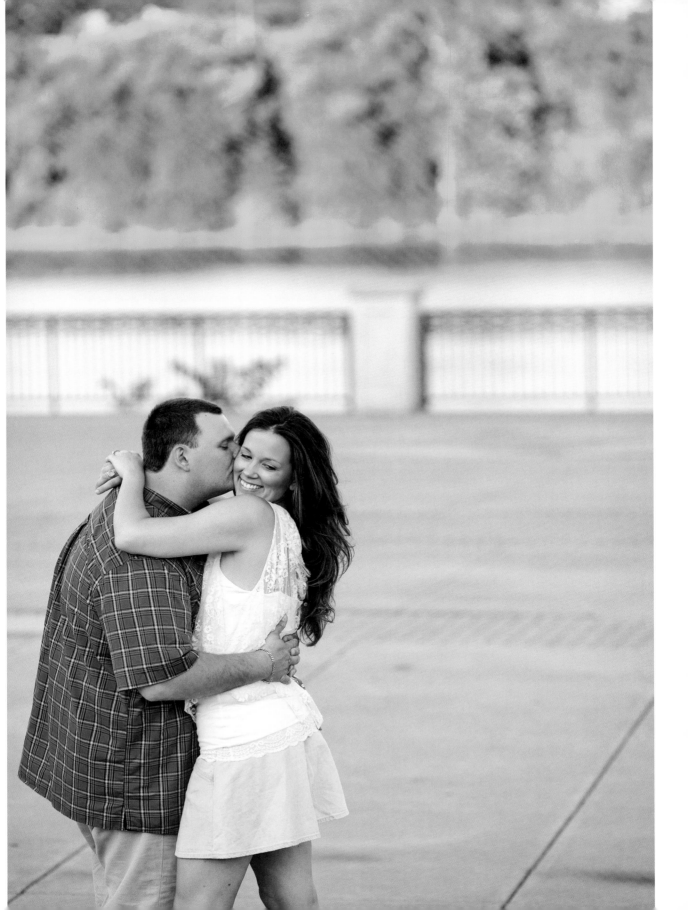

Rain Is Romantic

Every once in a while something magical will happen during an engagement session. This was one of those times. The forecast called for a chance of rain, and it looked like it was about to rain at any moment. We went back and forth wondering if we should reschedule; however, as we approached our appointment time, the sun came out.

Willing to Get Wet

It has been my experience that when the forecast calls for rain, but it does not, the most beautiful, colorful sunsets occur. I was so looking forward to that! The sun began to set and the sky was lit up with pink and orange. We were wrapping up when it started to rain. Initially, we all ran to our cars, but then I thought of the popular scene in the movie *The Notebook*. I asked my clients if they would be willing to get a little wet and they agreed. I grabbed my umbrella and a towel from my car and ran to the field. I managed to photograph these images while holding an umbrella

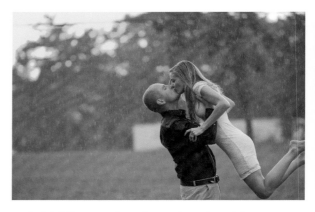

and shielding my lens from the rain with one hand, while holding a towel around my camera body and clicking the button with the other. It is not often that you get to have fun in the rain with the one you love. So, it was easy to get some natural, fun-loving expressions from this couple.

Equipment and Settings

All four images in this series were photographed with a Canon 5D Mark II with a fixed 135mm lens at f/2.5 and ISO 640. The shutter speeds ranged from $1/320$ second to $1/640$ second.

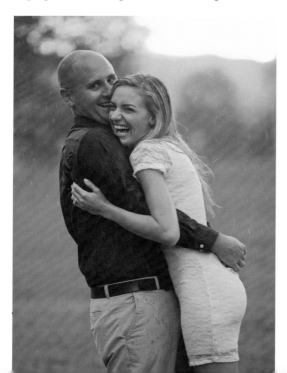

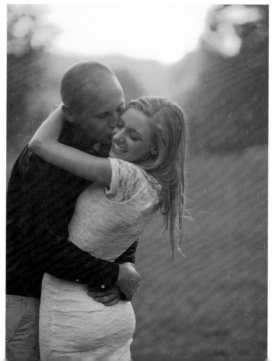

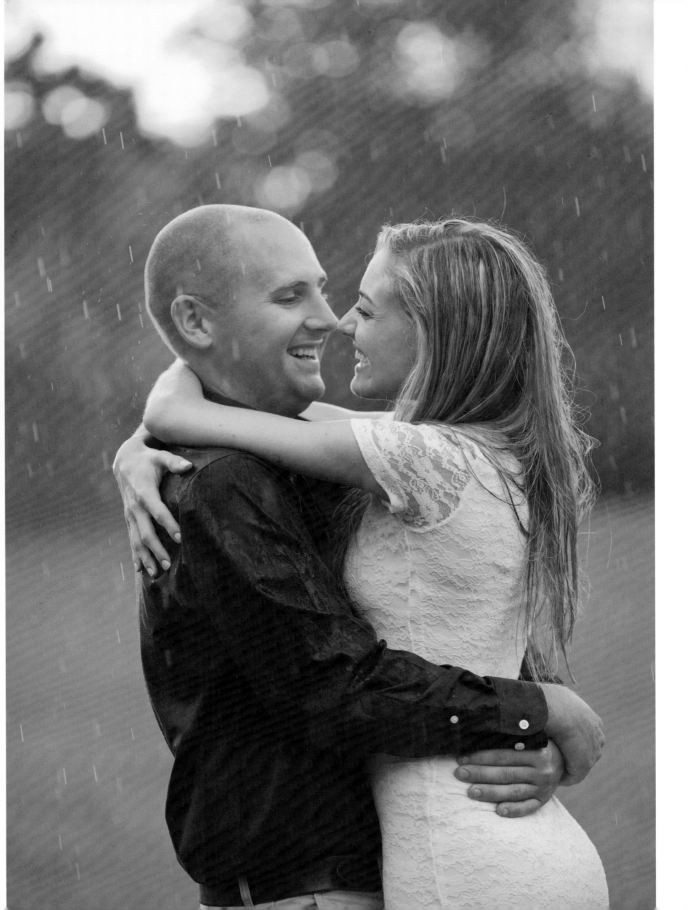

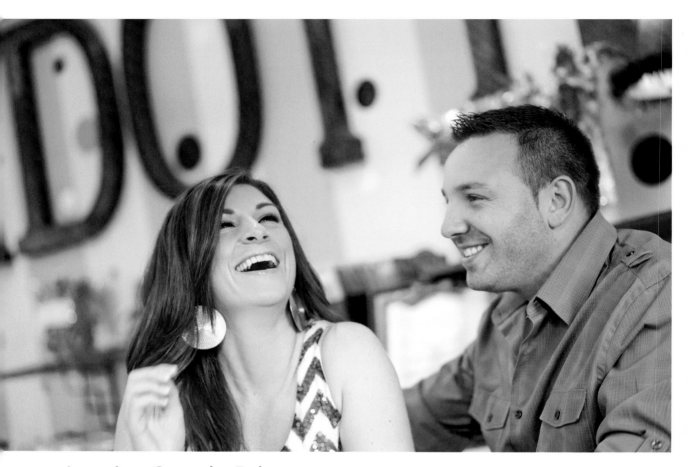

Location: Cupcake Bakery

These images were created in a local cupcake bakery. My client popped the question a few weeks before when he brought home cupcakes from this local shop; it only made sense for us to schedule the session at this bakery! There was natural light that streamed in from the front window, which was all that I needed.

Laughter —A Great Mood Setter

This couple certainly knows how to keep each other laughing! I wanted to capture them candidly in this cupcake shop, and laughter was the best way. This image (above) was created as I stood in the doorway as they faced the window. Because of the heavy design on the walls, I wanted my exposure to be at f/1.8 so that the background would blur and not distract from the couple.

Even Delivery Trucks Make Good Backgrounds

Outside the bakery was an adorable truck that made deliveries (facing page, top). I thought this would be the perfect way to show the couple and the name of the bakery. Because the light was shining harshly through a nearby tree, I needed to select a spot that had the most shade for my couple, as they leaned against the truck.

Equipment and Settings

All three of the images in this series were photographed with a Canon 5D Mark II, and the 24–105mm lens was set at 85mm. The facing page image and the image below were taken at f/2, 1/160 second, with an ISO of 640. The image to the right was taken at f/2.8, 1/125 second and ISO 100.

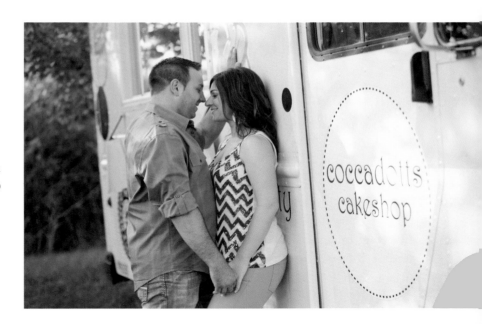

A Unique Approach to Photographing the Ring

My philosophy is that it is always important to photograph the ring during an engagement session. I love that we were able to have the cupcakes decorated saying, "She said Yes" which was an adorable way to announce their engagement. I wanted the groom-to-be to hold the cupcakes because the words on the cupcake were coming from his perspective. I thought it was an interesting way to display the ring that he purchased for his love!

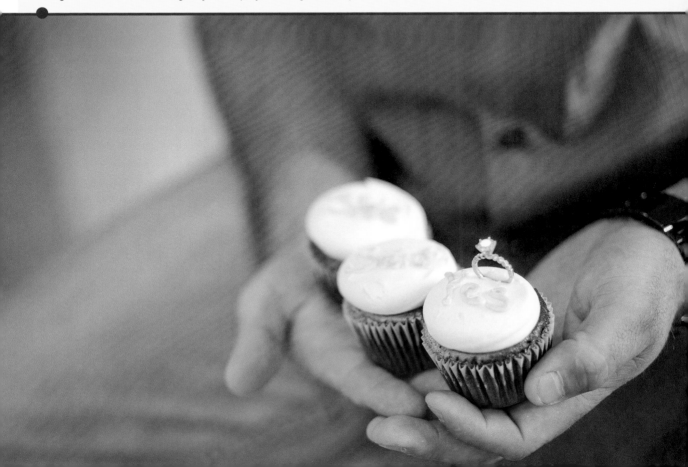

Color

This couple is wearing red, black, and light toned clothing. This simple, classical color combination comes alive as they are framed by the golden foliage and light. Coordinating the colors of background, clothing, skin tone, and light is not a simple thing to plan. That's why it becomes so important to recognize it when the elements are present in a particular setting. Remember that a difference in lighting can change how colors will coordinate.

Sometimes the Best Pose Is a Natural Pose

I love taking photos of couples sitting on the ground. Normally, I would pose the female to one side with her legs extended in the same direction;

however, when they sat on the ground, she snuggled right into her fiancé and her expression was priceless (below).

Coordinating an Image

This image at the top of the facing page was taken at a park near this couple's home. The golden light streaming through the trees that lined the red brick walkway and the colors in their wardrobe coordinated perfectly. I wanted the tree-lined path to frame this couple as a canopy. To achieve that look, I placed them at the front of the walkway and asked them to hold hands while they playfully walked and laughed. I quickly adjusted my settings in my camera to +0.33 over the metered light reading. I did this because the sun was very bright coming from the side and behind

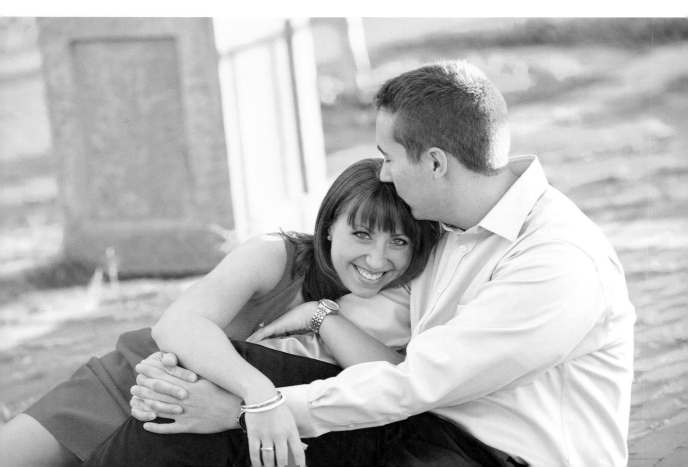

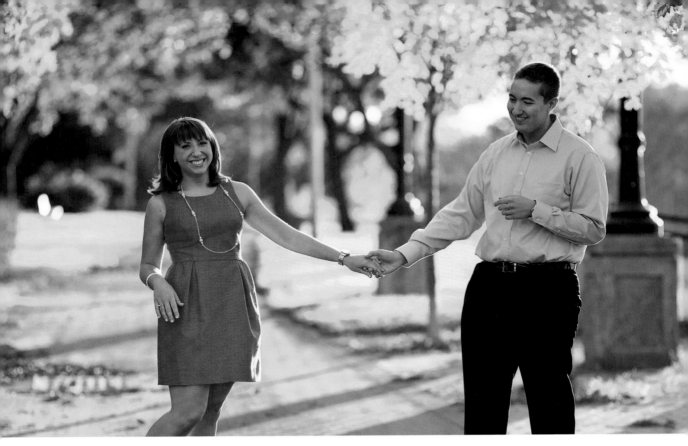

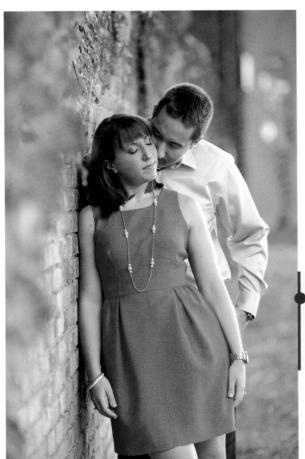

them and I wanted to make sure that their skin tones were properly exposed. As they continued to laugh, I quickly snapped the shutter.

Equipment and Settings

All three images in this series were photographed with a Canon 5D Mark II with a fixed 135mm lens. The upper image on the oppose page was photographed at f/2.5, $1/320$ second, and ISO 640. The image below was photographed at f/3.2, $1/250$ second, and an ISO of 400; and the lower image on the facing page was shot at f/2.2, $1/200$ second, and an ISO of 640.

Framing the Couple

The foreground and background have been thrown out of focus, and this effectively frames the engaged couple.

Cropping Can Show Emotion

I was completely in awe of my client's long eyelashes and wanted to come up with a pose that would properly draw attention to them (below). Cropping a photograph can make it up-close and personal and has the ability to show a lot of emotion and detail. Sometimes this closeness and emotion can be lost in a full-body image, so I am never reluctant to get in close and crop. It is very natural for a woman to rest her head on her guy's shoulder to relax; it is a sweet way to show affection.

Showing the Ring

I asked her to place her head on his shoulder and to put her left hand on his chest so we could see the engagement ring. An image like this is telling. The pose says "love and intimacy." The ring on the left had says, "engaged, but not yet married." Their eyes that are looking up and out of the picture frame as if to say, "Our future is together!"

To draw attention to her amazing lashes, I lowered my camera angle and asked her to look toward the sky, giving the viewer a great view of those fabulous eyes! Having her look up also ensured that her eyes remained wide open.

Equipment and Settings

All three of the images in this series were photographed with a Canon 5D Mark II, and the 24–105mm lens was set at 85mm at f/2.8. The ISO was 320. The upper-left image and opposite images were taken at $^1/_{1250}$ second and the lower, left image was taken at $^1/_{1000}$ second.

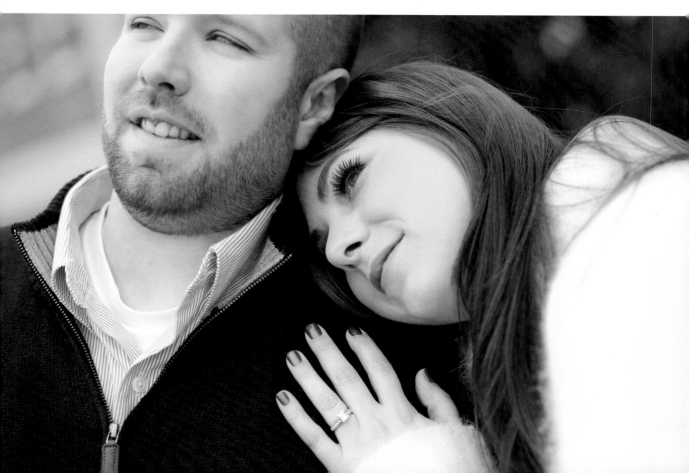

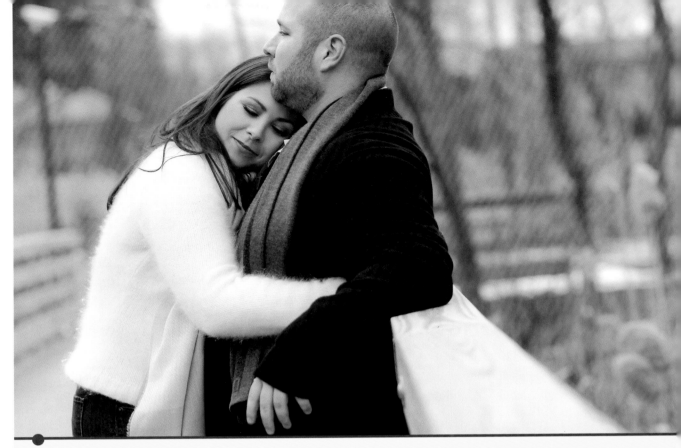

On Her Man's Shoulder

This image shows another adorable way to capture a woman resting on her man's shoulder. There are many different kinds of embraces that reveal various things about a couple. This pose suggests that they share an inner contentment and happiness.

Leading Lines

I backed up and used the fence to create a direct and centered line to the subjects. Backing up also placed the subjects into their setting by including more of the surrounding environment. There happened to be nothing else in the same focal plane as the couple, not even the seeded grasses to the right. This let me put everything, except the couple, out of focus. In essence, I placed a frame around the subjects that helps direct the viewer's eyes right to the couple.

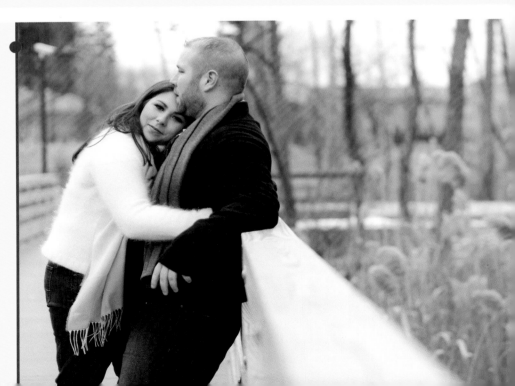

Glamorous Look Challenge

This couple invited me to their family home that sits on acres of land, and the photographic possibilities were endless. However, some outdoor environments are a challenge to photograph, especially in the winter. Jack Frost can nip at noses, making them red. Warm clothing does not always

I think this pose creates a glamorous look.

look sophisticated or elegant, so the cold outdoors can seem like a contradiction to glamour. We rose to the challenge, and my clients loved the results.

Snuggling is Always a Good Pose

There was a wooden bench nearby. I wanted to pose them in a way that looked as if they were sitting around a bonfire with friends (below). I asked them to snuggle up to each other, and I did a series of images, but this was one of my favorite photographs.

Equipment and Settings

All three of the images in this series were photographed with a Canon 5D Mark II, and the 24–105mm lens was set at 85mm. The settings were f/2.8 and ISO 160. The upper image on facing page was taken at $1/640$ second. The image below was shot at $1/320$ second, and the lower image on the facing page was captured at $1/400$ second.

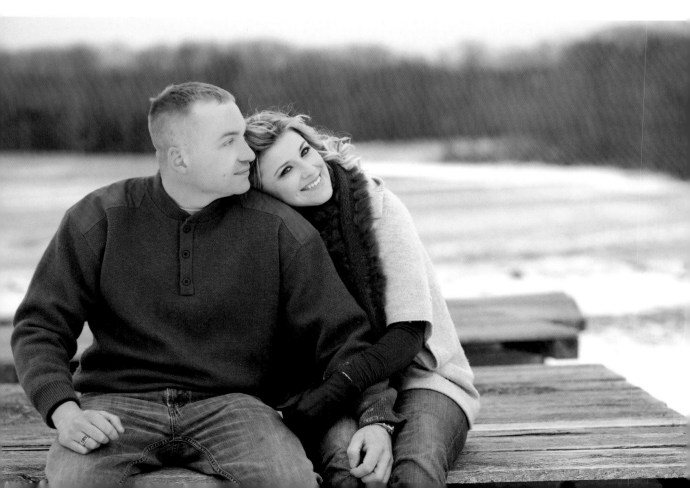

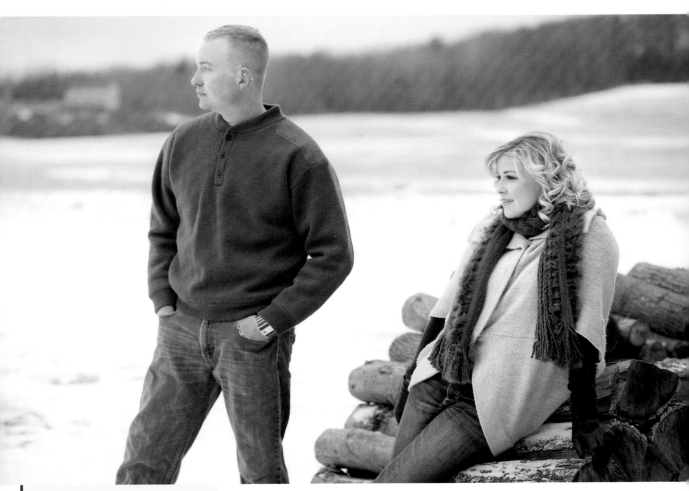

Creating a Glamorous Look to Contradict the Environment

As I pulled into the driveway, I noticed a stack of logs off to the right and immediately thought it would look cool to create part of the session next to them. I thought her outfit was fabulous and really wanted to show it off. I asked her to lean against the logs and her fiancé to stand close to her and instructed them to look off to the side. I think this pose creates a glamorous look, which contradicts the environment they are in.

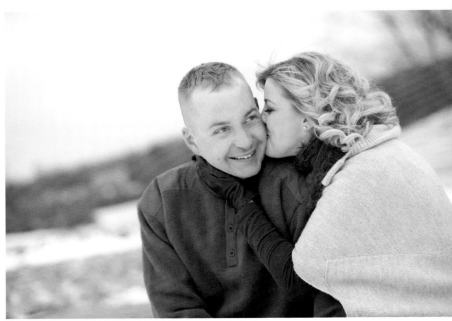

Meaningful Locations

Many couples have one or more special places that are meaningful because of an unforgettable event that occurred there. They often want to include one of these locations in their engagement photos.

It was really important to the couple that part of their engagement session took place where it all began.

DeJohn's restaurant in Albany, New York was very special to this couple because it was where they had their first date and where they got engaged. It was really important to the couple that part of their engagement session took place where it all began.

Equipment and Settings

All three of the images in this series were photographed with a Canon 5D Mark II, and the 24–105mm lens was set at 85mm. Images on the facing page were photographed at f/2.5, $1/100$ second. The ISO of the image on the facing page was 800, while the ISO of the lower-facing image was 1000. The image below was photographed at f/2.8, $1/400$ second, with an ISO of 1000.

Using Flash for Fill Light

We moved downstairs to the bar area for the continuation of their engagement session. I wanted this photograph to appear to be candid, which is why I asked her to look off to the side rather than directly at the camera. I was using my 580EX II flash at $1/3$ stop above ambient light to fill in the couple, while keeping the environment dimly lit.

Reflections on Location

I had noticed a mirror hanging on a wall that reflected the light from a nearby window in the upstairs dining area. Because of the small space, and knowing that I wanted to use my 85mm lens, photographing in the mirror not only helped light my couple, but it also gave me more room to work. I was able to capture this image after I asked them to share a slow dance. I love the little bit of reflection that is visible in the beveled corners of the mirror.

Light is the medium of photography, and a mirror can produce very interesting images when it reflects the light coming off objects. The result in this image is very alluring.

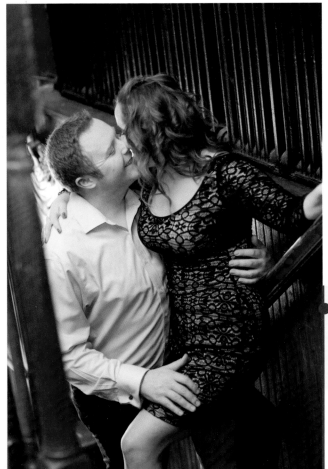

Diagonals Are Exciting

The couple are enfolded in each other's arms and the diagonals of the staircase and banisters, too. Even their limbs create diagonals.

Golden Light Can Be a Challenge

I love photographing during sunset for the amazing golden light it creates. This is the light of the golden hour, and the blue light becomes diffused. The intensity of the direct light is reduced and there is less contrast. Also, if you want less lens flare than I was going for here, shade your lens with your hand or a card.

Perfect Golden Light

When I was asked to go to Forest Hills (NYC Metropolitan area), I was unsure if the buildings were going to block the sunset. I kept my fingers crossed, and as the sun began to set, I noticed that one street was lit perfectly with the golden light that I was looking for during the session.

Posing

I asked my clients to simply kiss on the street corner. I liked that the street is lined with cars, making for a great backdrop. I also chose to photograph with a random pedestrian walking in the background, making the image appear as a candid moment and not just a staged kiss. Photographing directly into the sunset can pose a challenge if you keep your camera on automatic focus; more often than not, I switch to manual focus so I can quickly capture the mood and not have to worry about missing a cute moment.

Equipment and Settings

All three images in this series were photographed with a Canon 5D Mark II with a fixed 135mm lens and an ISO of 640. The upper image on the facing page was photographed at f/2.5 and 1/1250 second. The lower-facing-page image was photographed at f/2.5 and 1/2500 second. The image below was shot at f/2.8, and 1/640 second.

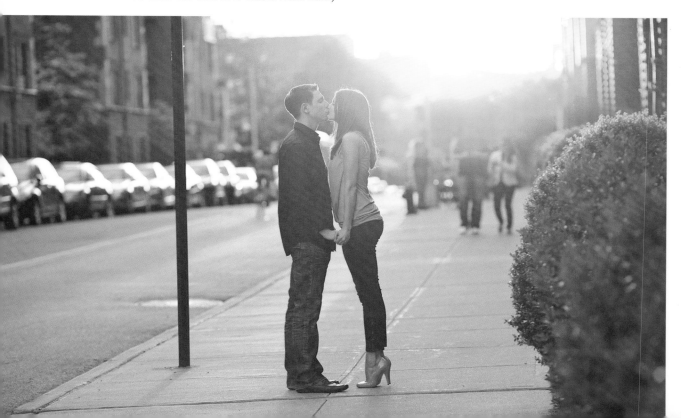

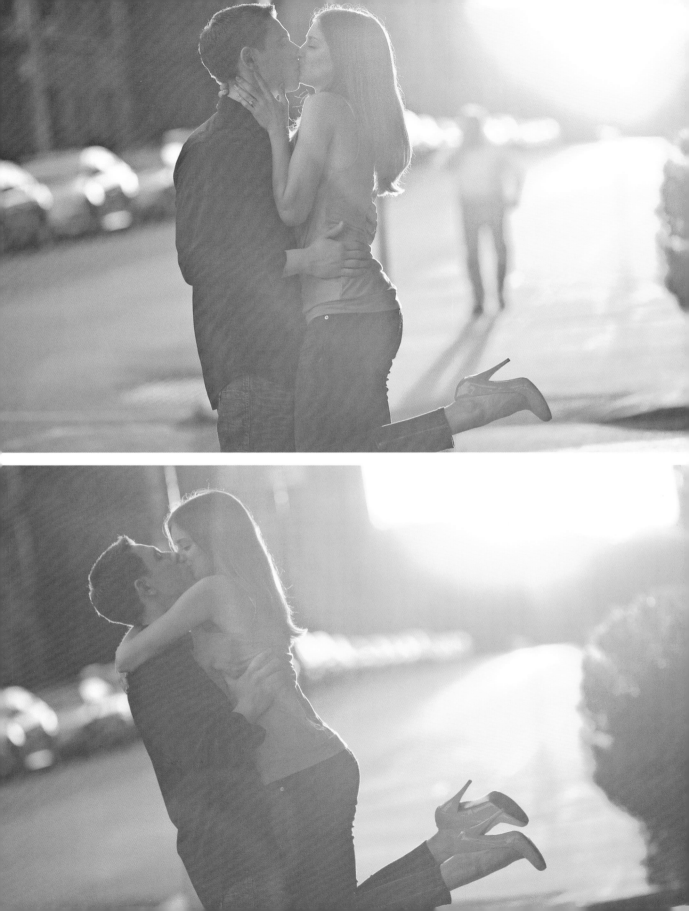

Location Selection

This couple expressed their interest in being photographed in an open field for a portion of their engagement session. I drove around prior to their arrival so that I could find a location that would suit their needs. When I saw this white fence, I knew this was the spot! I loved the location even more when I saw the young lady in a red-and-white striped dress. I thought the horizontal lines in the fence, paired with the dress, looked amazing.

Posing in the Location

You can do a lot in an empty field with a white fence. I began by capturing a traditional *eyes-on-the-camera* portrait (below). Placing the couple against the fence with his arm around her immediately took the pose from what could have been very formal to a more casual look. Locking their hands together and tilting their heads so they touch resulted in body language that any viewer can interpret as, "I adore you."

A second option (facing page, top) was to pull the couple away from the fence and photograph them sitting casually in the grassy field. He gently held her face as he kissed her nose, which added great warmth to the feeling of this photograph.

For the third alternative (facing page, bottom), I had him sweep her up into his arms and posed them next to the fence, as they kissed.

Equipment and Settings

All three images in this series were photographed with a Canon 5D Mark II with a fixed 135mm lens. The exposure was f/2.5 at ISO 500. The image on the facing page and the lower-left image were photographed at 1/320 second. The upper-left image was photographed at 1/500 second.

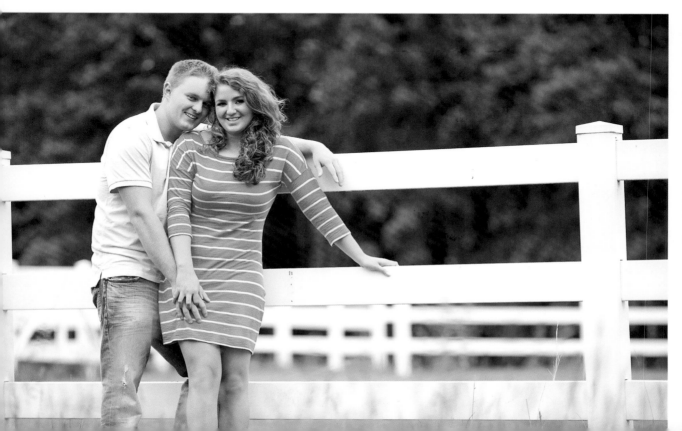

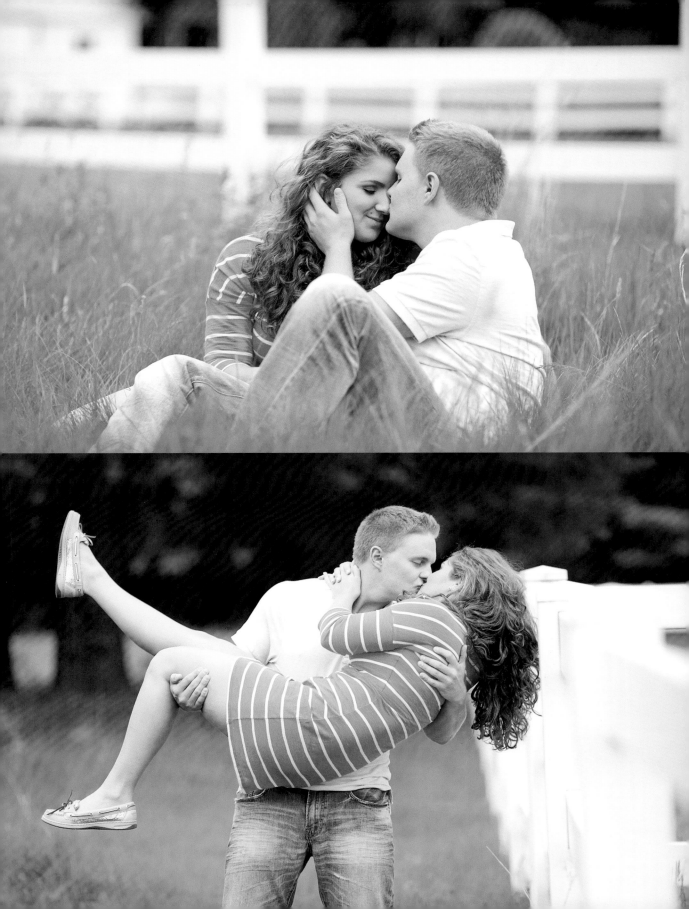

Docks and Boats as a Backdrop

This engagement session took place in Wells Beach, Maine. We started on one of the local beaches; however, as the sun began to set, we noticed that we were not in a great location for the golden light. We drove to a nearby marina where the docks and boats would make for interesting backdrops. The other advantage to changing our location from the beach to the marina was that it was more private. In my experience, I have noticed couples feel more comfortable when they do not have to worry about people watching them.

A Low Camera Angle

I asked the couple to sit on the dock and I lowered myself to their position; in fact, I was lying on my stomach when this portrait was created.

I wanted to work from a lower camera angle in order to have some of the boats behind them in the image. Their happiness is evident with their beaming smiles; this image exemplifies the comfort and joy they have found within each other.

Equipment and Settings

All three images in this series were photographed with a Canon 5D Mark II with a 135mm lens. For each, the aperture was f/2.2 and the ISO was 250. The upper image, facing page, was photographed at $^{1}/_{160}$ second, the image below was shot at $^{1}/_{500}$ second, and the lower image, facing page, was photographed at $^{1}/_{250}$ second.

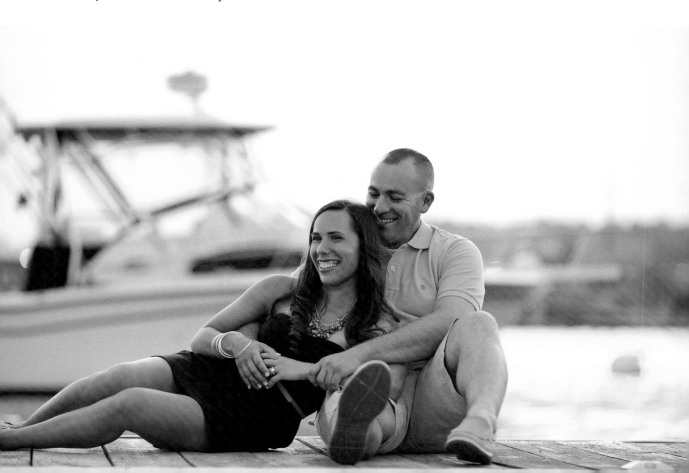

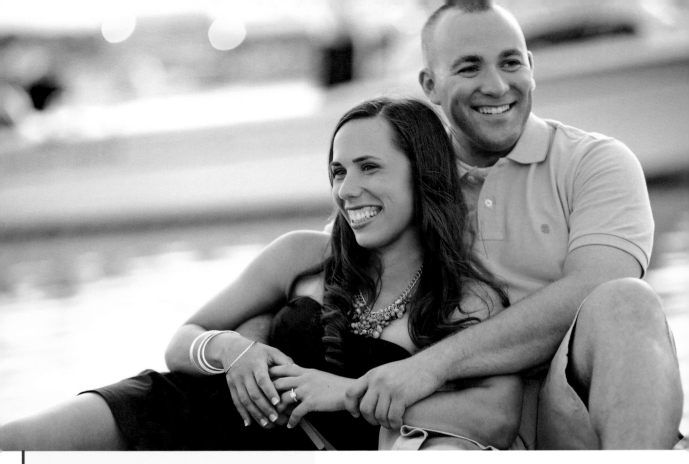

Enough Variations to Choose From

The image, above, is my favorite. The soft focus of the background is enough to suggest the boat's movement. The smiling subjects present a welcoming gaze to both the right and the left. The lens flare gives a magical twinkle to the image. But it is difficult to predict which images will be most appealing to the couple and which images will suit their printing or online needs. Make sure to have enough variations for them to choose from.

We drove to a nearby marina where the docks and boats would make for interesting backdrops.

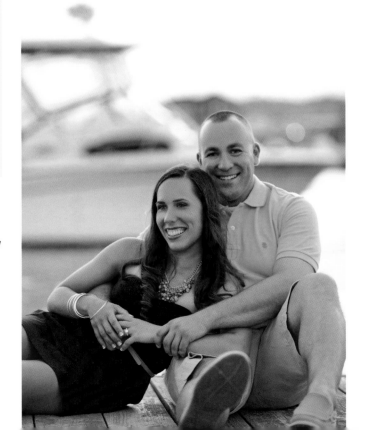

Utilizing Harsh Light for My Advantage

Albany, NY, has so many beautiful locations, and this couple knew exactly where they wanted to be photographed. I was thrilled with the location they chose. We started at a local park, and as the sun began to set, we changed locations. I was in awe of the beautiful sky and knew that this second location was going to produce some of my favorite images from this session. This location had large lights set up because of construction in the surrounding area; I knew that I could make this work to my advantage.

Equipment and Settings

All three images in this series were photographed with a Canon 5D Mark II. The upper image was photographed with an 85mm lens. The exposure was f/2.2, 1/60 second, and ISO 1000. The lower images were photographed with a 135mm lens. The exposure was f/2.2, 1/100 second, and ISO 640.

Golden Light Before Dusk

The sun gave off some amazing golden light before dusk that was reflected in one of the nearby buildings; it actually made the building look orange. I thought that the orange-looking building would look great as a backdrop, and would provide a great contrast to my couple, who were dressed in dark colors.

Whenever I photograph couples, I prefer to focus on one person at a time; this is what I was trying to achieve here by having her look at the camera, while her fiancé looked in a different direction.

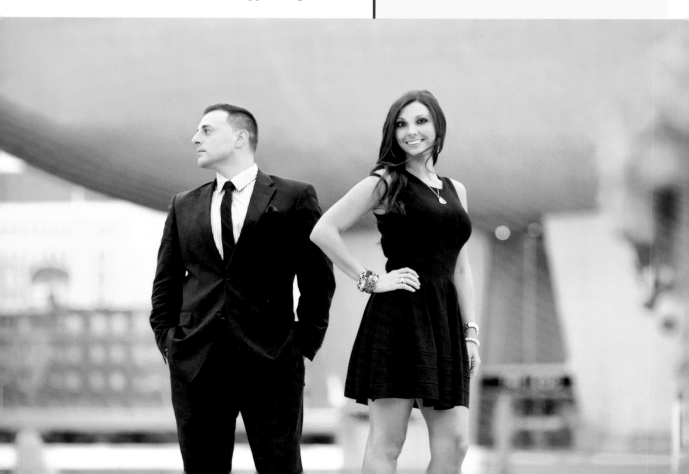

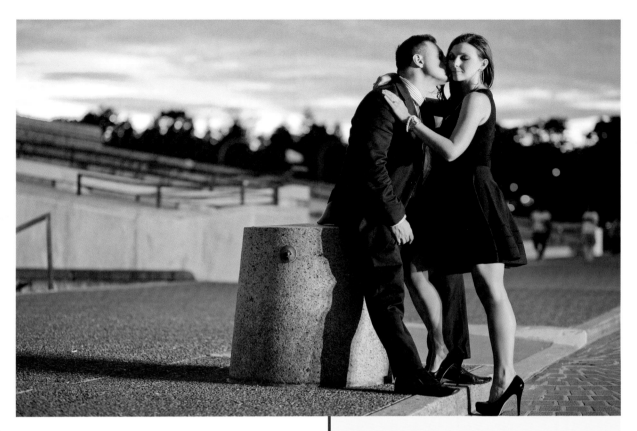

Harsh Light

I placed the engaged couple in front of the harsh light, knowing that the sky would pop with color as I focused on them. I love this pose because of the dichotomy; it is soft and romantic against a dramatic sky and harsh light. These contrasts, along with the couple's embrace and kiss, make for a beautiful and exciting image.

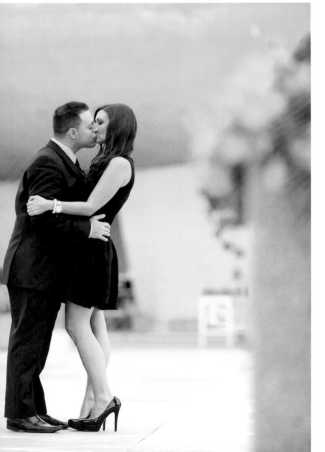

Lighting at Dusk

The light at dusk gives the photographer a range of effects as it transitions from light to dark. The angle and amount of sunlight change dramatically at the end of the day. You can see a big difference between the two images on this page, both taken in the waning light of day, but almost an hour apart.

Location

This image was created on a private roof terrace in downtown Albany. When we arrived on the rooftop, I could not have asked for a more perfect view; the buildings were in an ideal alignment with the sun. One thing that was ideal about this rooftop was that the background buildings were recognizable as city buildings, but they were so far away that they would be out of focus while framing the couple.

Body Language

This couple stands together in a way that expresses their love and connectedness. They both have an expression of happiness while appearing to look back at the viewer in delight. Body language and expression can communicate a great deal!

An Intimate Portrait with Genuine Emotion

I wanted to compose a more intimate portrait that shows the engagement ring as well as her genuine emotion. By asking her to pull him in close, I was able to capture the desired image.

The couple is bathed in late-day splendid light. Each of their heads is back lit with light of this golden hue (below).

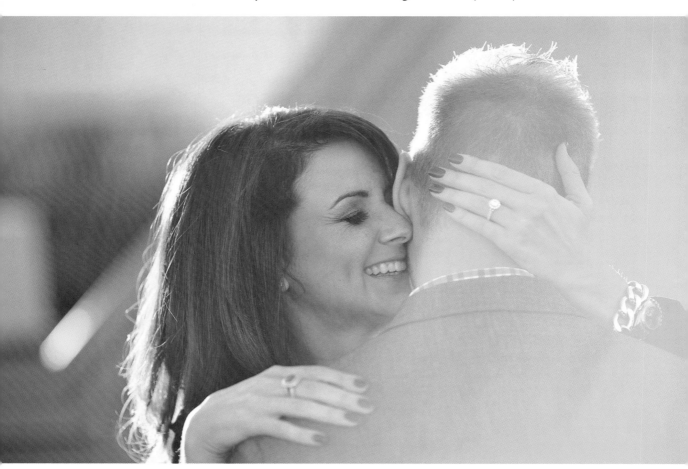

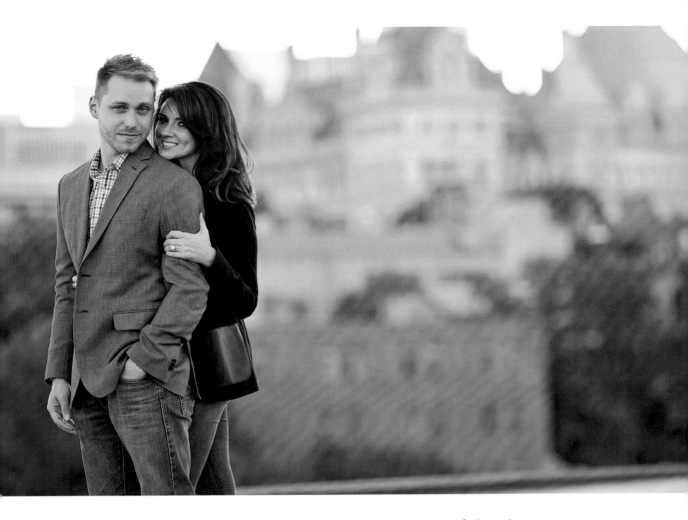

Body Language Conveys Love

For a modern twist on a traditional pose, I posed the man in front of the woman (above). I love how she is holding on to him as he leans back into her; his head tilted toward her shows their connection. Recognizing body language is very important; I want to make sure that every position and pose conveys love. This image shows just that. I was photographing at a relatively low angle in order to capture some of the warm, golden light that was shining on them. If my angle had been too high, the light would not have appeared as nice and soft. However, if the angle was too low, I would not have framed them so nicely in the soft-focus buildings in the background.

Equipment and Settings

Both images in this series were photographed with a Canon 5D Mark II and an 85mm lens. The image on the facing page was photographed at f/2.5, $^1/_{1250}$ second, and an ISO of 250. The image below was photographed at f/2.2, $^1/_{1000}$ second, and ISO 250.

Recognizing body language is very important; I want to make sure that every position and pose conveys love.

The Race to Location

Sunset images on a wedding day go hand-in-hand with frosting on a wedding cake. We were racing against time to make this sunset photograph happen; it was late September and the sun was setting much faster than we anticipated. We had a twenty-minute drive from the church to the reception venue, all while the sun was setting.

The flash helped light up their skin tone without blowing out the beautiful colors in the sky.

Equipment and Settings

The two images in this series were photographed with a Canon 5D Mark II. The facing-page image was shot with a 50mm lens. The exposure was f/1.4, $\frac{1}{60}$ second, and ISO 800. The image below was photographed with the 24–105mm lens, which was set at 32mm. The exposure was f/4, $\frac{1}{60}$ second, and ISO 4000.

Sunsets in RAW Format

When we arrived at the reception, we raced to a nearby field where I made this photograph. I quickly changed my camera settings to allow as much light in as possible without compromising the quality of the file. I always photograph sunsets in RAW format because the natural warmth of the scene can be enhanced in postproduction. As it grew darker, I asked my assistant for my Canon 580 EX II flash for a little fill light. The flash helped light up their skin tone without blowing out the beautiful colors in the sky. I asked the couple to share a kiss and this photograph became an instant favorite and the cover for their album.

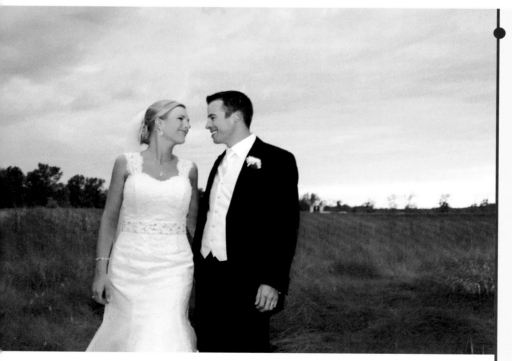

Having Two Cameras at the Ready Makes My Job Easier

There are always two cameras on my shoulders when I photograph a wedding; it gives me the ability to quickly switch back and forth between two lenses and is less time consuming than changing lenses on one camera. This photograph was created with my secondary camera, which had a 24–105mm lens already attached, giving me the opportunity to get this beautiful photograph of the new husband and wife looking at each other. As I worked in postproduction, I pulled some fill light through the RAW file, which helped make the grass look almost like a painting.

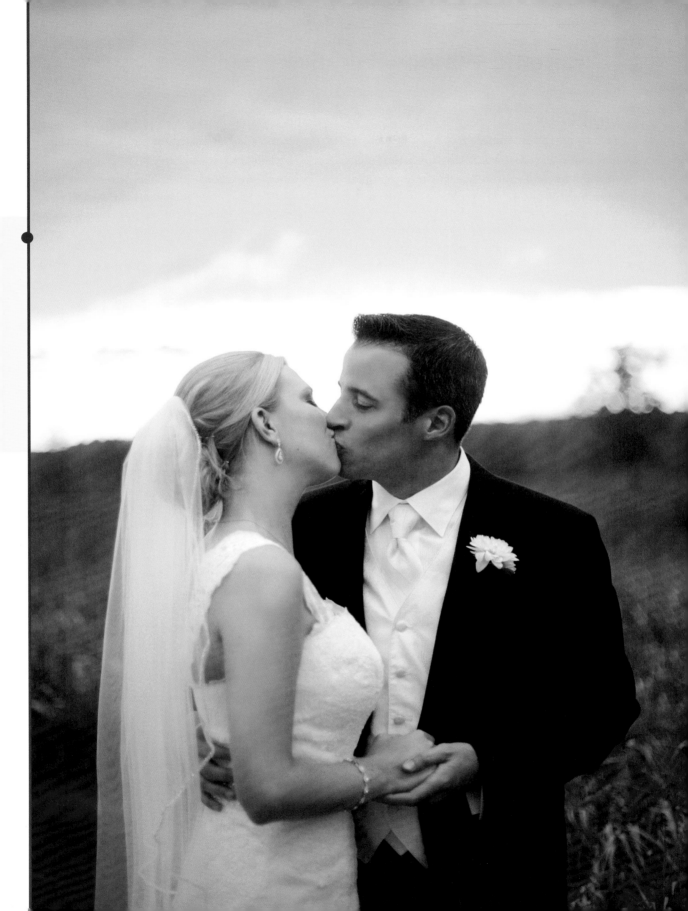

Dramatic Window Light

First Look

This couple chose to do a *first look* on their wedding day. A *first look* is that special moment coordinated and captured by the photographer when the bride sees the groom in his tuxedo and the groom sees his bride in her gown for the first time. For the ultimate effect and the best expressions, this takes place before the ceremony. Some couples choose to do a *first look* so they can complete all formal photos ahead of time, which allows them to enjoy the cocktail hour with their guests.

After the first look, I went to the bridal suite to capture a few more images. The suite was dimly lit, and I was instantly attracted to a window that had a chair next to it. I asked the bride to sit in the chair and directed the groom to stand behind her and strike a casual pose with his hand in his pocket. Having them look out the window gave me a light that would highlight their faces and gradually fall off across their bodies, creating a more dimensional look. This image was photographed at f/1.8, giving me the flexibility to selectively focus back and forth between the bride and groom for added variety.

Equipment and Settings

All three of the images in this series were photographed with a Canon 5D Mark II. I used a 50mm lens set at f/1.8 and an ISO of 320. The facing-page image was photographed at $^1/_{500}$ second, while the images below were photographed at $^1/_{250}$ second.

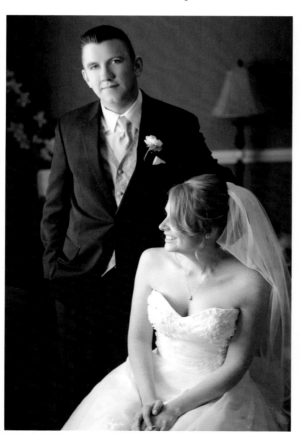

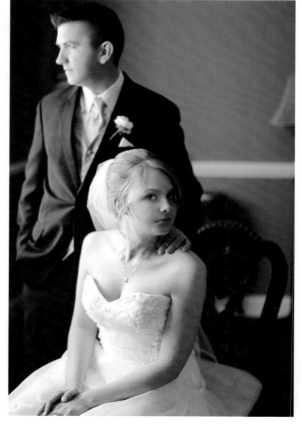

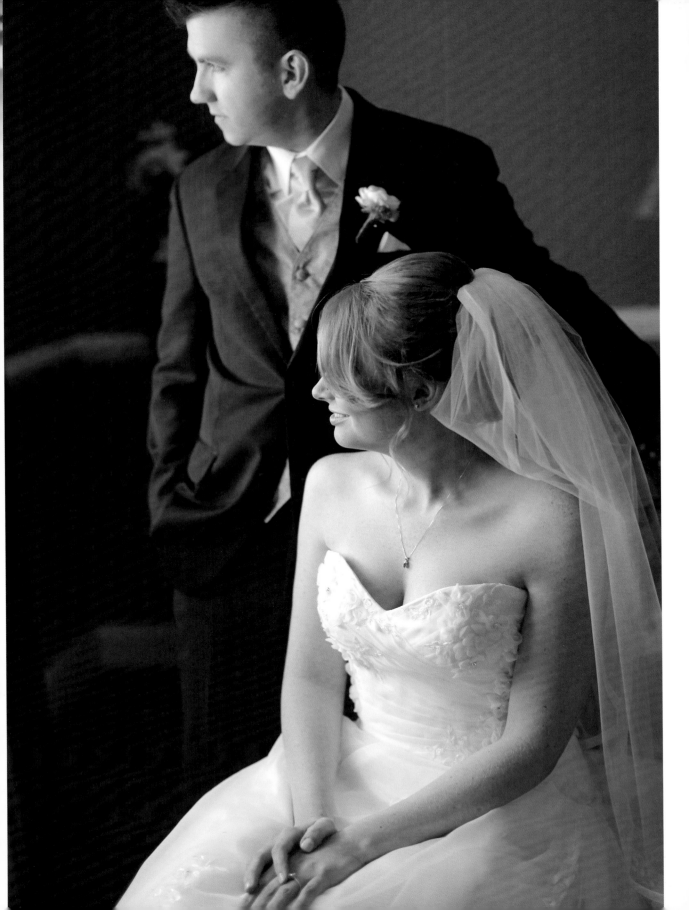

No Harsh Light or Shadows

This wedding took place in mid-October with a 1920 theme. In fact, the gown this bride is wearing belonged to her great grandmother. The sky was slightly cloudy and overcast, which is my preferred weather because there is no harsh light or heavy shadows with which to contend. I like to photograph with my camera white balance settings on cloudy or shade, which helps to create a nice warm tone in the image.

Equipment and Settings

All of the images in this series were photographed with a Canon 5D Mark II with a 200mm lens. The exposure was f/2.8 at ISO 160. The image below and upper facing image were photographed at $\frac{1}{320}$ second, while the lower facing-page image was photographed at $\frac{1}{800}$ second.

I had her sit on a nearby rock and asked her to put some weight on her right hip to create length in her body.

Newlyweds Alone Time

I wanted to capture the bride and groom having some "special" time alone. I stood off to the side and positioned myself at a lower angle so that I could create a nice depth of field with the tall grass. I instructed them to hug and just soak in this moment as newlyweds. I created this sweet image just as he kissed her head.

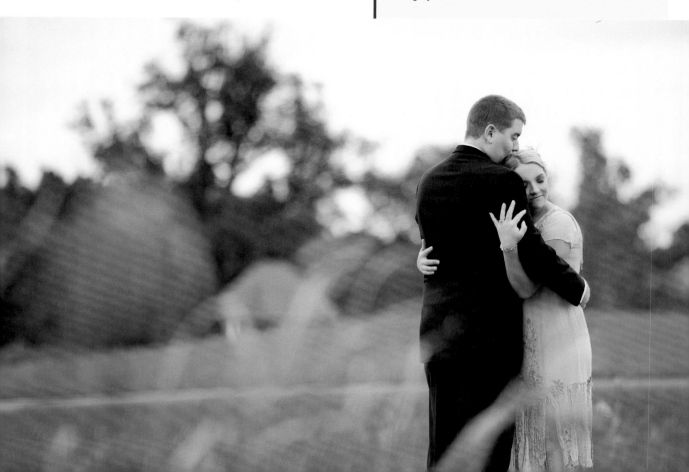

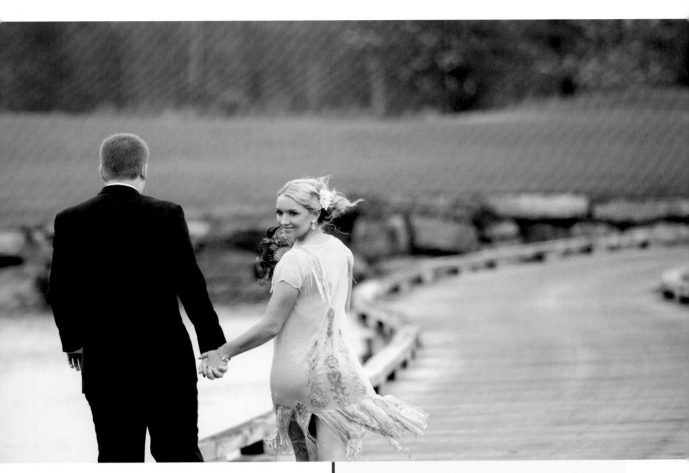

Captured Dress Movement

I asked the couple to hold hands and walk away from the camera. When I determined that it was just the perfect moment, I asked the bride to turn and face me, creating this pose, which captured the movement in her dress.

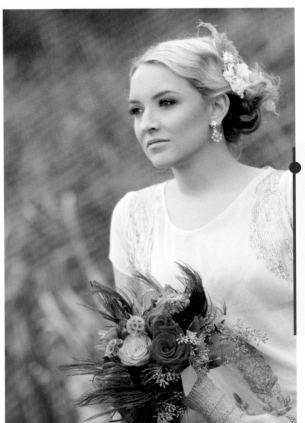

Highlighting the Bride

At some point on the wedding day, it is important to capture solo images of both the bride and groom. This bride reminded me of a popular fashion model that I have seen in magazines; I loved her bone structure and natural beauty. I had her sit on a nearby rock and asked her to put some weight on her right hip to create length in her body and to stare past my camera lens. She gave me the look I was hoping to achieve.

Coordinate and Be Prepared

This moment was captured during the *first look* part of the session. The groom turned around to see his bride waiting for him and grabbed her hand in delight and repeated, "Wow! Wow! Wow!" A photographer needs to learn to coordinate parts of the sessions like *first look* and be ready for those moments that occur just once and for only a split second.

Equipment and Settings

All three images in this series were shot with a Canon 5D Mark II and 24–105mm lens, set at 85mm. The ISO of the three images was 250 and the shutter speed was $1/160$ second. Both facing-page images were photographed at f/1.8, and the image below was shot at f/2.2.

I wanted the background to be out of focus so it would not compete with my subjects.

Placing the Focus on the Bride

We walked to a nearby path that was lined with trees for a pop of color in the background. I wanted to focus on the bride, but still have the groom in the frame. I asked the bride to stand at an angle for the most flattering view. I was able to capture the detail in her flowers and dress, which was the desired look I was seeking.

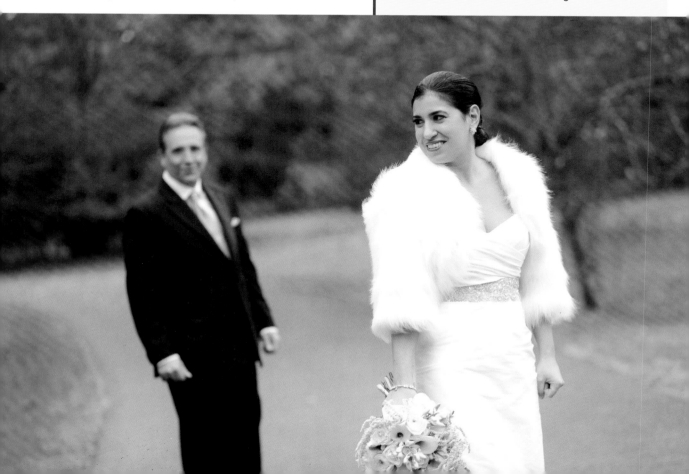

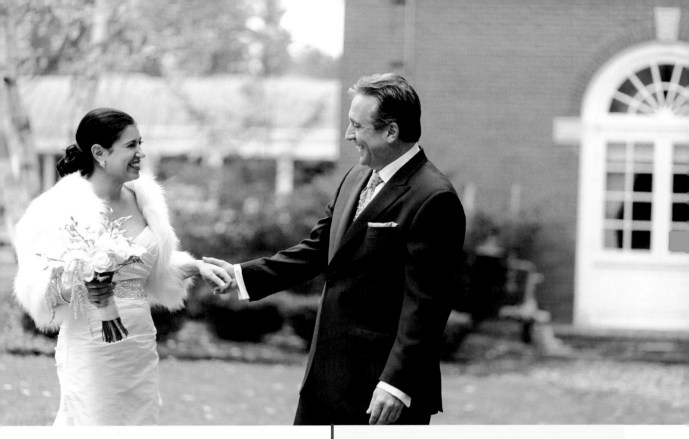

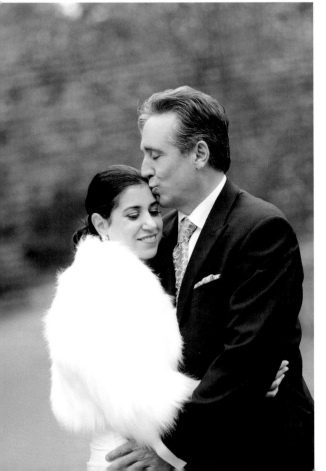

Prepare in Advance

I found the red brick of the hotel next to the yellow trees extremely pleasing and I wanted to frame the couple using that as the background. The groom waited for his bride in the grass next to the hotel and when she tapped him on the shoulder, he turned around. Preparing in advance for this moment, my camera was set at f/1.8, and I used my favorite lens, Canon's 85mm. I wanted the background to be out of focus so it would not compete with my subjects, making sure that all of the attention would be focused on their reaction.

The groom turned around to see his bride waiting for him and grabbed her hand in delight and repeated, "Wow! Wow! Wow!"

New Location

This wedding took place in Atlanta, Georgia, and since my home base is New York, I was looking forward to photographing in a new area. Photographers always hope that the weather cooperates on the day of a wedding, giving us the opportunity for beautiful outdoor portraits, but the weather has a mind of its own. However, while we cannot control the weather, we can control the light. I was looking forward to beautiful sunlight, but instead I was greeted with clouds and rain. Luckily, the venue was stunning and there were many amazing locations for photographs. I was also thankful for all the windows that helped light the bride and groom naturally. In the entryway of the venue was a circular couch and a glass doorway that worked perfectly for the pose and lighting I had in mind. The glow of the ambient light created a nice orange hue in the background. I asked the bride to extend her arm so that I could see the groom's wedding band when he placed his hand on her arm. A sweet, simple kiss created a nice intimate moment for these newlyweds!

Outdoor and Ambient Light

The brick detail in the lobby of the venue was beautiful and I wanted to use it as a backdrop. In the left photograph (below), my couple was lit nicely by the outdoor light shining through the front doors, while the ambient lighting was creating a nice warm glow on the brick. I did not want the lines in the brick to distract from the couple, so I chose to photograph at f/2.0 to create a smooth, blurry effect.

Standing in the same spot (bottom, right), I asked the bride to hug her new husband with her eyes closed and her face toward the camera. This is one of my favorite images.

Equipment and Settings

All three of the images in this series were photographed with a Canon 5D Mark II. For the facing-page image, my 24–105mm lens was set at 85mm. I set my camera at f/1.8, 1/100 second, and ISO 800. For the two images below, I used a 135mm lens and my camera was set at f/2.0, 1/80 second, with the ISO at 2000.

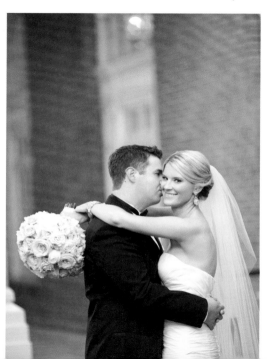

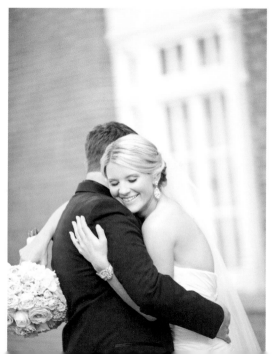

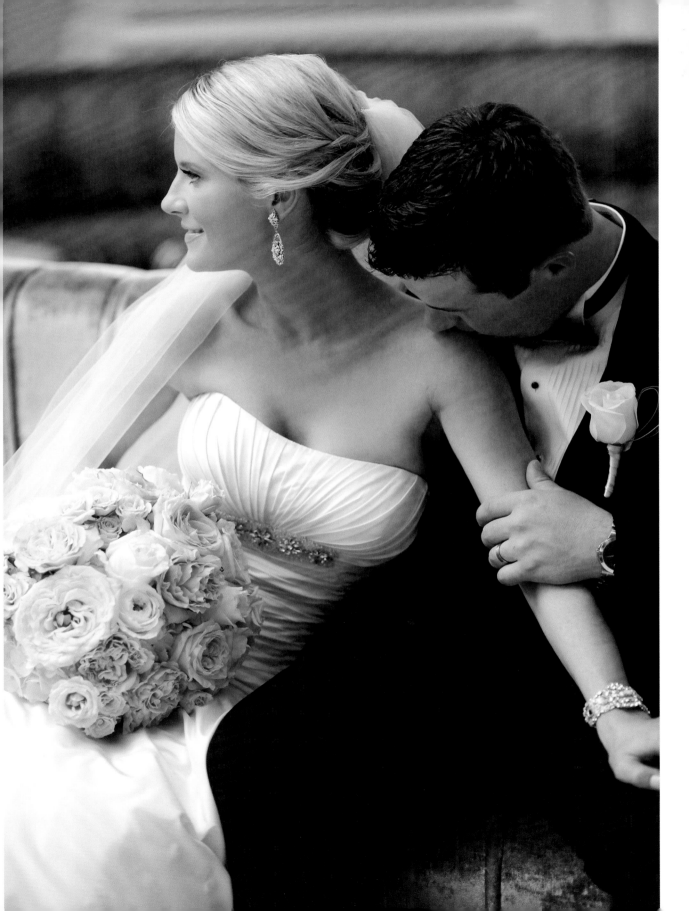

Plenty of Time

We had plenty of time before the ceremony to capture bridal portraits on this spring day. Beautiful, green trees and tall grass surrounded the hotel where the bride was getting ready. It was the perfect setting for the image I was trying to create.

About the Image

I wanted to put the bride in the field (facing page) so the grass would pick up the green in her bouquet; I also loved the texture of her dress against the grass. The day was overcast, which worked to my advantage. With harsh sunlight, it is not always possible to find a shaded spot in the middle of a grove without getting crazy shadows.

I love creating portraits at a wedding with my 135mm lens because of its sharpness. I set my f-stop to f/2.5 so the background would not compete with the bride's face and asked her to turn slightly to her right (my left) and look over her shoulder to create a more casual portrait, yet still showing the simplistic beauty of her dress.

A Second Location

It was a bit chilly, so in an attempt to warm up, we walked into a vacant building that had an interesting looking empty fountain (bottom, left). I wanted this image to appear as if she casually positioned herself, and I just happened to be there.

As we walked down the hallway in the building, we came across some beautiful window light (bottom, right). Wanting to capture my bride's makeup with a peaceful look on her face, I asked her to close her eyes until I was ready to capture the image. This relaxed the facial muscles, helping to create this stunning look.

Equipment and Settings

All three images in this series were photographed with a Canon 5D Mark II with a fixed 135mm lens at f/2.5. The facing-page image was photographed at $1/1000$ second with an ISO of 250; the two images below were photographed with an ISO of 125, with the left image shot at $1/100$ second and the right image shot at $1/60$ second.

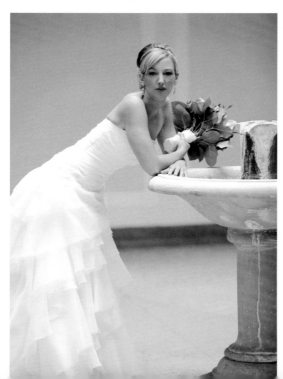
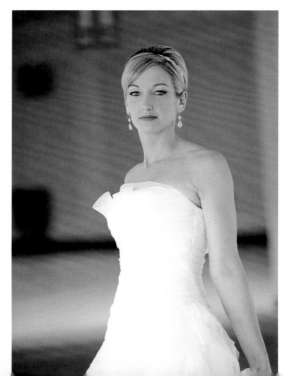

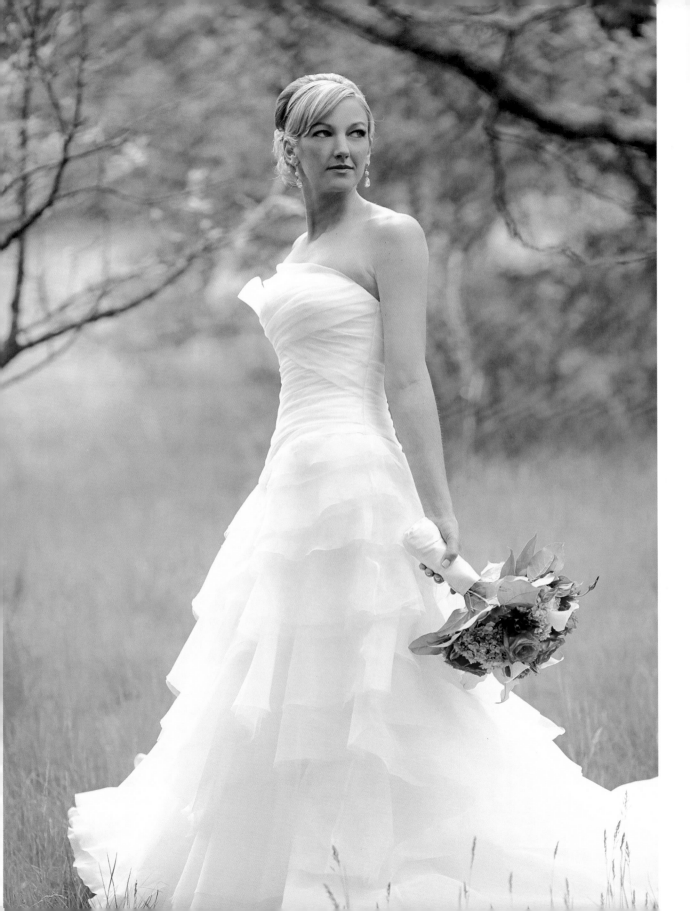

Cocktail Hour

These images were created during the cocktail hour following the church ceremony. We were restricted to a small area to photograph the couple; I decided to first pose them in the grass and work from a higher angle so that the couple was not restricted to one backdrop for their portrait session. I have noticed that when I ask couples to sit down, they become instantly relaxed.

Posing and Composition

After the groom was seated on the grass, I asked the bride to lean into him. He was leaning back on his hands, so the bride needed a pose where she could hold herself up. I helped her get into a position that would be easy for her and still keep her dress clean. As she leaned forward, I asked her to put her left hand on her right arm, which created this beautiful diamond formation between her head, arm, and shoulder (facing page).

I focused on the bride and asked the groom to turn his head so I could see his profile. I photographed at f/3.2, giving me some nice depth of field without blurring the groom too much. The sun was blocked by trees, creating a nice soft look, while lighting their faces perfectly.

Expression

This bride was full of beauty and glamour; she reminded me of a young Elizabeth Taylor. The expressions that she gave me reminded me of those that I might see in old Hollywood photographs. I instructed her on the look I was trying to achieve, and she nailed it (below)!

Equipment and Settings

The two images in this series were photographed with a Canon 5D Mark II with a 50mm lens. I shot at f/3.2, with an ISO of 160. The facing-page image was photographed at $1/160$ second. The image below was shot at $1/200$ second.

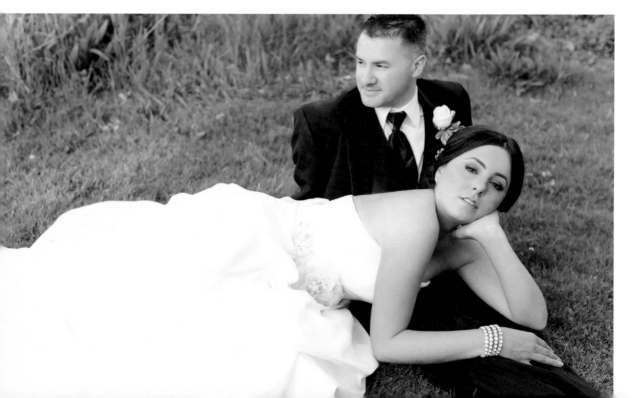

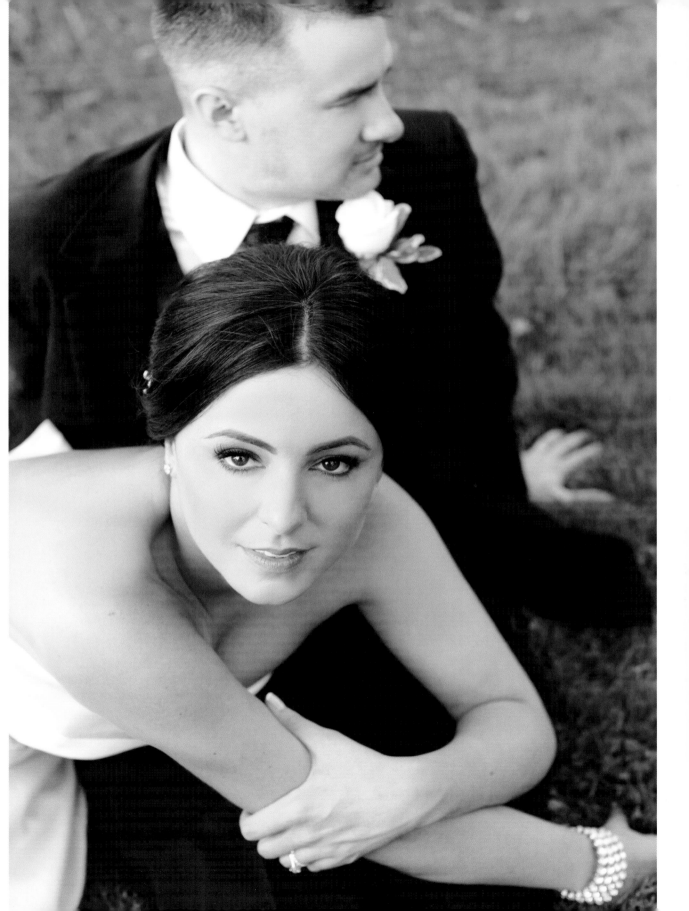

Planning and Scouting

In the cold winter months we lose hours of daylight. In New York City, I can almost count on it being completely dark by 5:00PM. When I met with this couple their ceremony began well after the sunset. I knew that I was going to need artificial light for their portrait session.

Before the wedding I scouted out the requested portrait location and loved the backdrop it provided. There was a large, wide stairway surrounded

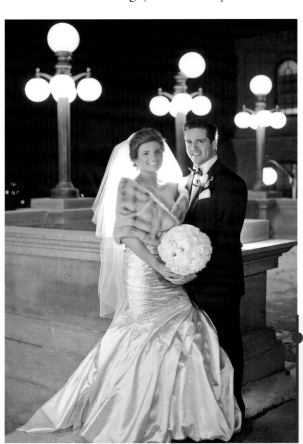

Working with Two Flashes

I placed the couple on the stairs, moving my flashes with each new pose. Working with two flashes was a must in order to create a portrait with dimension. The on-camera flash was used as fill and essentially create a brighter ambiance. A second off-camera flash was set up behind the couple at 1/3 stop above the main flash setting. By doing so, the second flash created a beautiful backlit highlight around the subjects. It really makes the couple pop off the page!

by globe light posts. I noticed a ledge that would be useful for setting up an off-camera flash.

After the ceremony, we headed to the portrait location and I knew exactly how I wanted to pose the couple! I was working in a limited time frame. I had to be thorough and quick.

Equipment and Settings

All three images were shot with a Canon 5D Mark II. For the facing-page and left images, I used an 85mm lens. The camera was at f/2.5 and ISO 1000. Both of these images used a Canon Speedlite 600EX-RT. The lower-left image was photographed using a 50mm lens. The exposure was f/1.2, 1/100 second, and ISO 1250.

Creating Depth

An off-camera flash on the ledge behind the couple produced separation between the subjects and the background. Controlling light in a night-time setting can bring photos from ordinary to extraordinary.

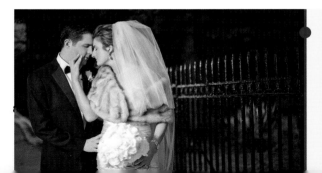

Other Artificial Light Sources

Here, I used the Westcott Ice Light, a portable, daylight-balanced light source that runs on battery power. My assistant held it from a distance to light my subjects and a portion of the iron fence. A street light behind the couple (to the left) also provided some warm-toned light in the background.

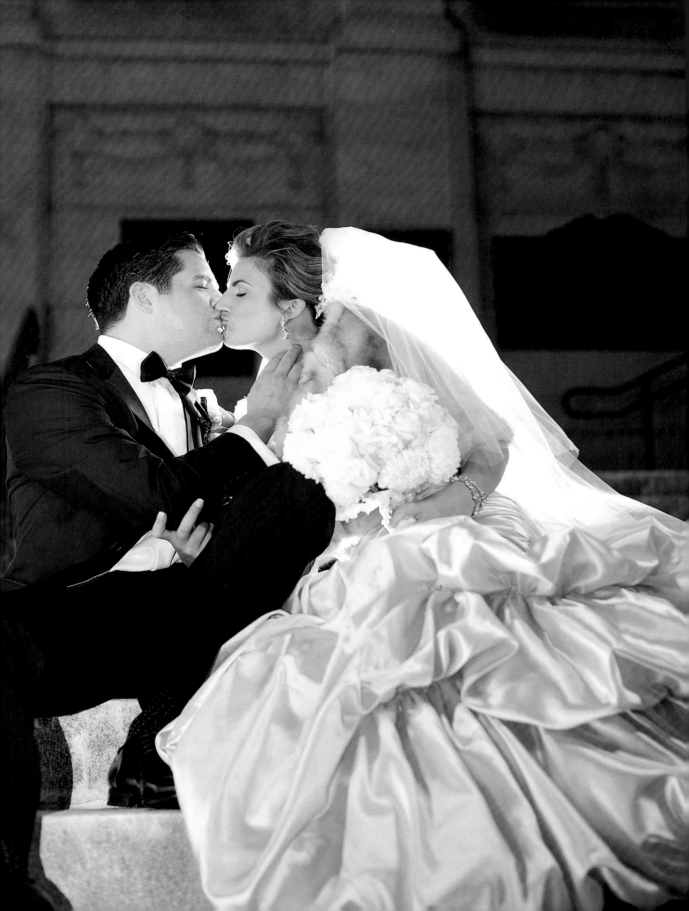

No Time Constraints

This photography session took place after the actual wedding, which was awesome! Whenever I have the opportunity to work with a couple after the wedding, I always jump on it because there are no time constraints; we do not have to hurry

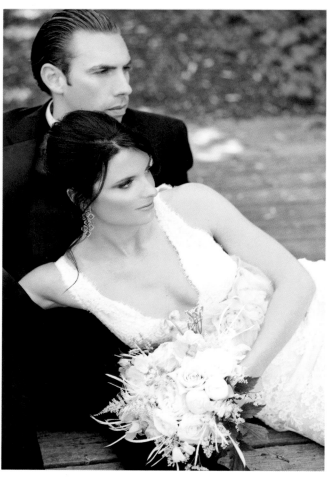

A Pose to Show Off the Dress

I loved the back of this wedding dress and I wanted to show it off, hence this pose. The lighting worked perfectly because we were under a covered walkway and the light was coming in at a nice angle. By turning her body and face toward the light, I was able to highlight her eyes and showcase all of the lace detail in her dress. With the groom standing behind her looking forward, the direction of the light created a nice soft split lighting pattern on his face.

through the poses or rush to be at the reception. In addition, I find that the bride and groom are more relaxed after everything is over.

Equipment and Settings

All three images in this series were photographed with a Canon 5D Mark II and an 85mm lens. The lower-left and facing images were photographed with an aperture of f/2.8 and an ISO of 250. The facing-page image was shot at $1/400$ second. The lower-left image was shot at $1/1000$ second. The upper-left image was photographed at f/2.8, $1/320$ and ISO 160.

Whenever I have the opportunity to work with a couple after the wedding, I always jump on it . . .

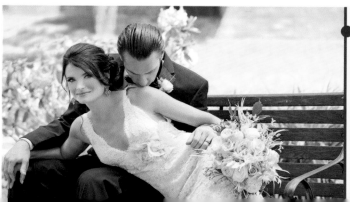

Adding Color and Creating Leading Lines

I was drawn to this bench and the flowering bush that was next to it; I thought the flowers would add a nice pop of color to the image. Because she was in a beautiful lace gown, I wanted to show off as much of the dress as possible. By instructing her to lean into her husband, we created a nice long line with her body.

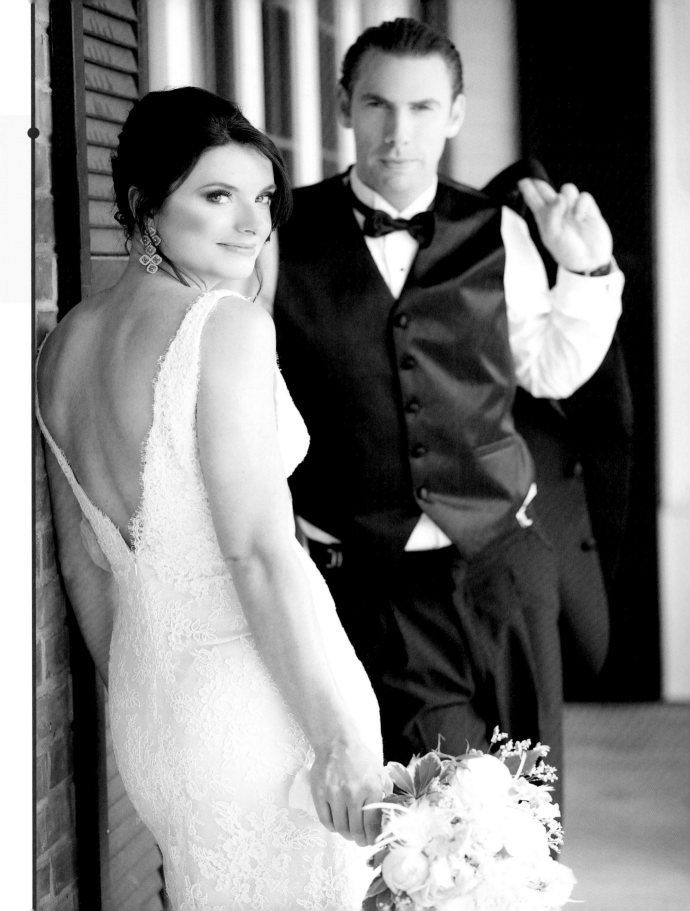

The Location

This wedding took place in June in downtown Albany. The architecture at the State Education Building is stunning with its huge columns and a covered walkway; it is a very popular location for wedding photographs because of its grandeur. After creating a couple of traditional images along the columns, I wanted to switch things up.

Equipment and Settings

All three images in this series were photographed with a Canon 5D Mark II and a 50mm lens. Each was shot at f/2.8 and ISO of 320. The upper image on the facing page was photographed at $1/800$ second, the image to the left at $1/400$ second, and the lower image on the facing page was photographed at $1/640$ second.

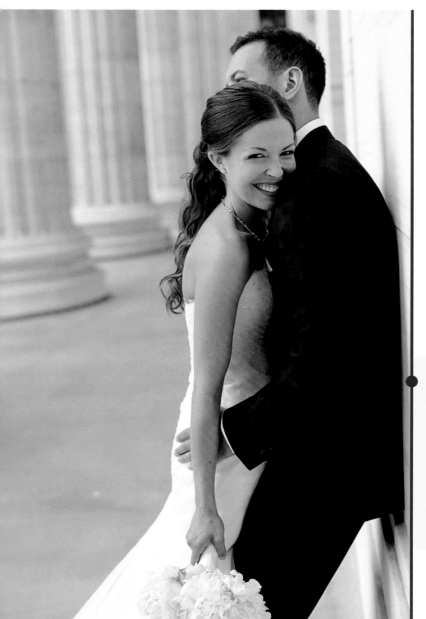

By posing the couple against the wall, the columns could still be seen, yet the primary focus remained on the bride and groom.

Grandeur Can Be Your Friend

As mentioned above, this popular photo location is known for its grand columns. I wanted the columns to be in the frame, yet not in a way that would distract from the main subject: the bride and groom. By posing the couple against the wall, the columns could still be seen, yet the primary focus remained on the bride and groom.

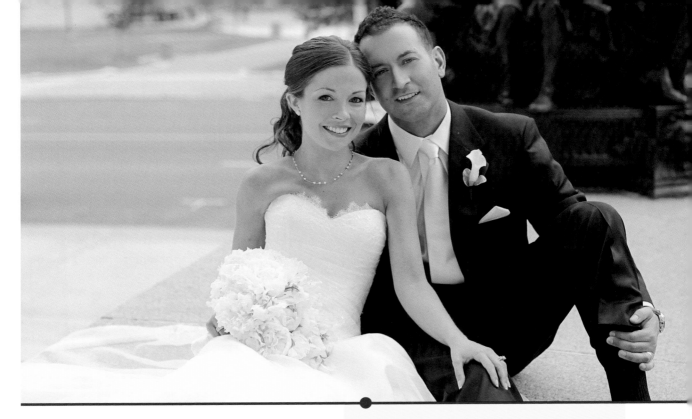

Using My 50mm Lens

I walked with the bride and groom out on a ledge along a staircase and asked them to sit down and to bring their heads together for a different take on a traditional image. Because I did not have much room to back up, I chose to use my 50mm lens, which helped frame this image to my liking.

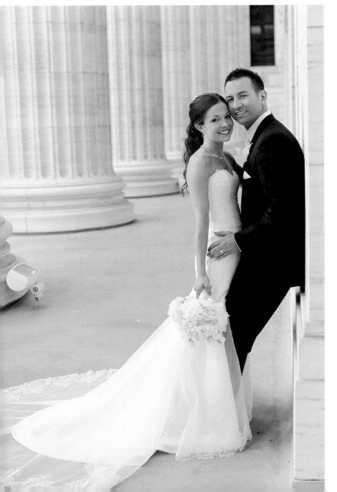

I walked with the bride and groom out on a ledge along a staircase and asked them to sit down and to bring their heads together . . .

Why I love Prime Lens

I do not typically like to photograph with a zoom lens during portrait session. I am a huge fan of prime lenses. I love how crisp an image can look when shooting with a prime lens. My favorite lens is the 85mm. I use it all the time! The reason I prefer this lens is because I can shoot at a distance and also up close.

I wanted to use the 85mm prime lens for this particular setting because I knew I wanted the option to photograph wide and then be able to step in a little bit closer for a more intimate capture.

Wide, Then Close

This scene (upper-facing-page image) had so much character! I asked my couple to share a slow dance-spin, twirl, dip, kiss-I wanted to show them having fun!

After this image was captured I moved to a nearby cottage where I asked the couple to sit on the porch (image below). I cropped in tight as I asked the bride to pull her new husband in for a kiss! As she followed my instruction, I asked the groom to shut his eyes for a more playful and candid appearance.

Equipment and Settings

All three images in this series were photographed with a Canon 5D Mark II using an 85mm lens. The camera was set at f/2.5, 1/800 second, and ISO 250. The lower image on the facing page was at 1/400 second and ISO 160.

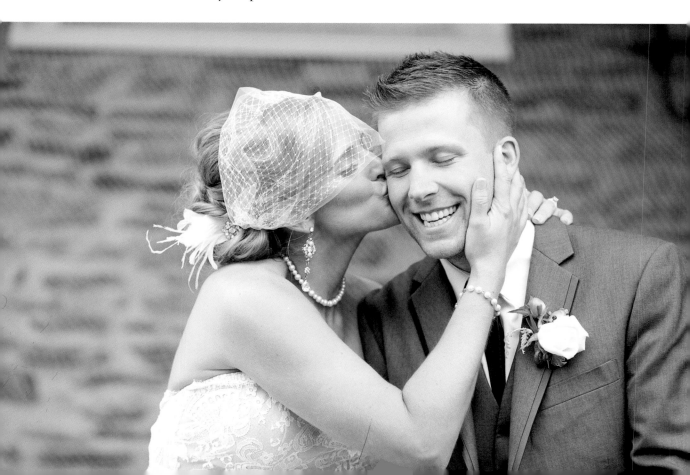

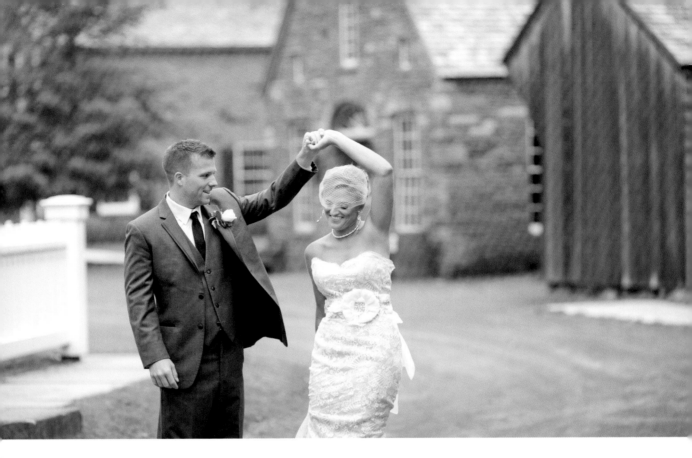

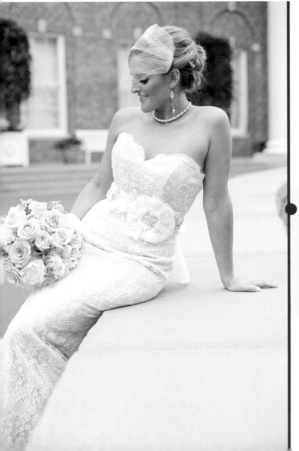

I wanted the option to photograph wide and then be able to step in a little bit closer for a more intimate capture.

Photographing from a Lower Vantage Point

After focusing on the bride from a distance, I wanted to move in a little closer. By photographing from a low vantage point, I was able to capture her flowers and also the lace details in her gown.

Lighting and Posing at Sunset to Create Mood

After the bride and groom finished some of the formalities at the reception, I was able to sneak out with them for a few sunset pictures. At this point in the day, the bride and groom are typically more relaxed and will enjoy a moment alone for a few more photographs. The reception venue was surrounded by a park and trees, which was not ideal for sunset; however, I could see the golden light ahead of me.

Equipment and Settings

All three images in this series were photographed with a Canon 5D Mark II with a 135mm lens. The facing-page image was photographed at f/2.5, 1/200 second, and ISO 200. The two images below were photographed at f/2.5, 1/800 second and ISO 320.

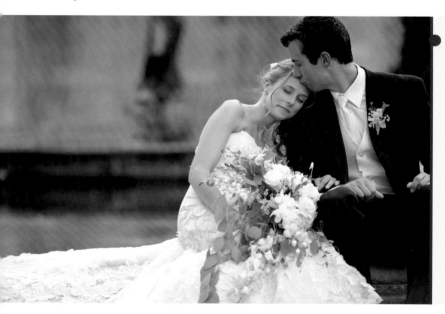

Body Language Tells a Story

When I photographed this couple before the reception, I asked them to sit on a ledge at the pond. I liked this pose because you can see the detail in both her flower bouquet and her dress. I also liked how their body language is focused on each other; it makes the image appear more natural, as if they were sitting there without my presence.

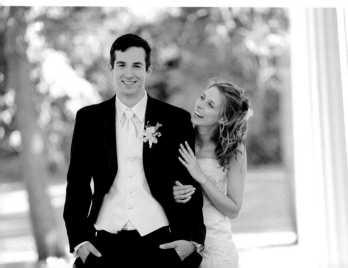

Focus on the Groom

With this pose, I wanted the focus to be on the groom. By positioning the groom with his shoulders square to the camera and his feet shoulder-width apart, he commands the camera. Placing the bride slightly behind him helps the viewer focus on the groom.

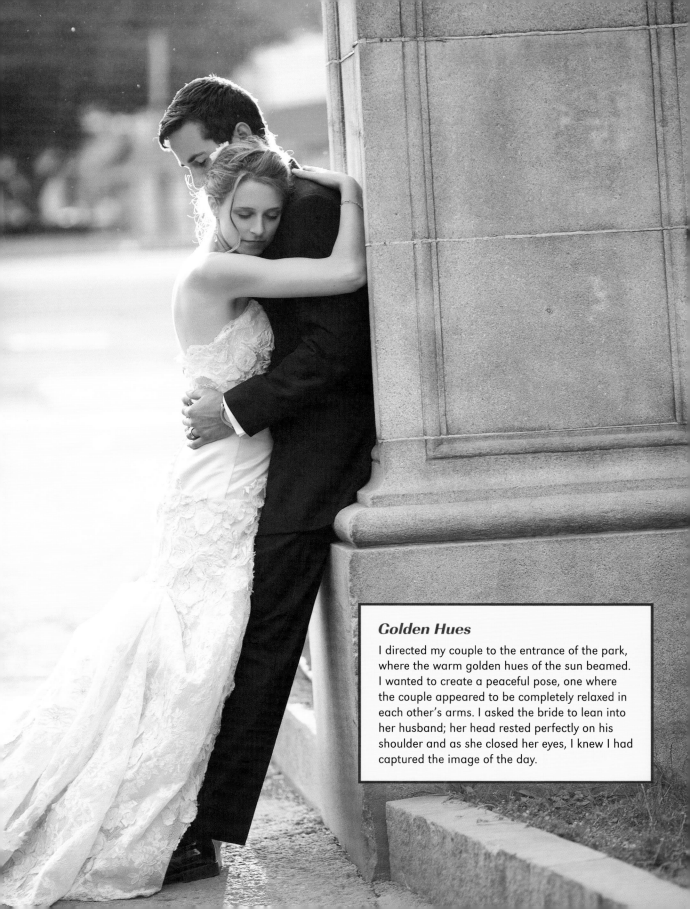

Golden Hues

I directed my couple to the entrance of the park, where the warm golden hues of the sun beamed. I wanted to create a peaceful pose, one where the couple appeared to be completely relaxed in each other's arms. I asked the bride to lean into her husband; her head rested perfectly on his shoulder and as she closed her eyes, I knew I had captured the image of the day.

Rose Gardens Are Perfect Locations for Portraits

These images were created during the interval between the church and the reception in a popular rose garden, which was the perfect location for portraits in Schenectady, NY. Although the roses are beautiful and vibrant, this garden has more to offer than just roses. The entry has a brick walkway with columns that I knew I wanted to use for portraits. It was late in the afternoon, and although the sun was not directly overhead, the light was still harsh. Keeping this in mind, I found a location in the garden where there was some open shade, allowing me to light my bride and groom with a softer light without any harsh shadows. I love the warm-red sky behind them as they shared a kiss at sunset.

Equipment and Settings

All three images in this series were photographed with a Canon 5D Mark II and an 85mm lens. The upper-left image was shot at f/2.8, $\frac{1}{80}$, and ISO 400. The lower-left image was photographed at f/2.5, $\frac{1}{2500}$, and ISO 320. The facing-page image was shot at f/2.8, $\frac{1}{40}$, and ISO 640.

Mysterious and Peaceful

I love the mysterious look from the bride, as the groom stood peacefully and held her hands.

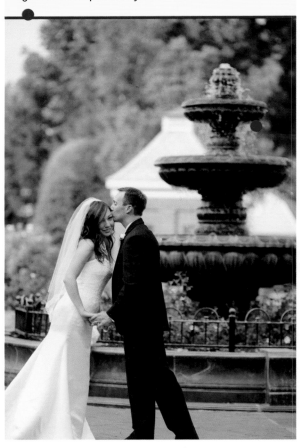

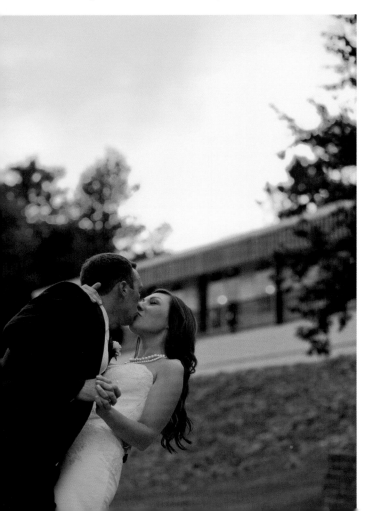

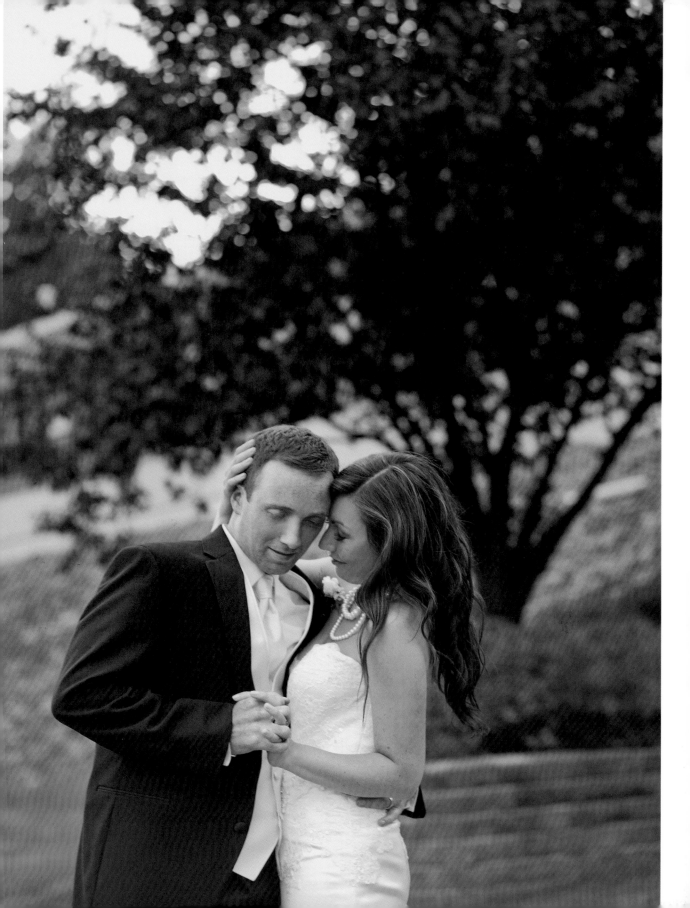

Location: The Hamptons

This wedding took place on a beach in the Hamptons on Long Island in New York. I had never been to the Hamptons and I knew this beach wedding was going to be gorgeous.

Lighting Challenges

This couple chose to do the *first look* and complete all photographs before the ceremony. There was a long dock that led from the venue to the water; I knew instantly that this was where I wanted to

begin their session. Lighting the portraits on the dock required a lot of control. There was a clear-blue sky, with the sun directly overhead, so using a diffuser was a must. Moments after they saw each other for the first time on their wedding day, we were ready to begin. I had my assistant stand next to me with the diffuser, which kept the harsh light out of the image. I had to choose a lens that was not super wide because I did not want the viewer to see the shadow lines from the diffuser. The 85mm lens worked as I intended, and the bride and groom were lit perfectly.

Equipment and Settings

All three images were photographed with a Canon 5D Mark II. The facing-page image was photographed with an with an 85mm lens (f/2.8, $1/1600$ second, and ISO 100). The lower-left image was photographed with a 135mm lens (f/2.0, $1/8000$ second, and ISO 100). The upper-left image was photographed with a 135mm lens (f/2.5, $1/2500$ second, and ISO 100).

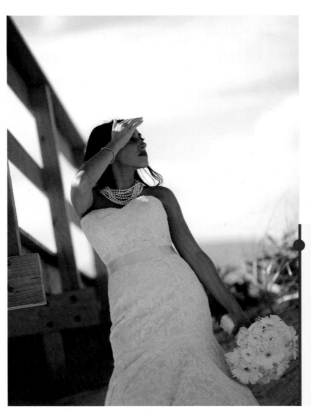

A Focus on the Dress

This is one of my favorite images from the day because it has an editorial vibe. After the bridal party and bride-and-groom portraits, I asked the bride to stay with me. I found a very small shaded area next to the dock staircase where I asked the bride to stand. I wanted to focus on the dress and necklace, so I positioned her so that her body was facing the camera. By turning her head away and using her hand to shade the sunlight, the viewer's eyes focuses on the dress and necklace.

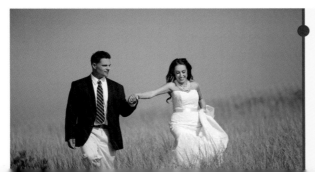

Shadow and Highlight

Next to the dock was a field with tall grass. Because we were photographing during the middle of the afternoon, I thought that I would have to pull in some fill light in camera post-production. Fortunately, the light was coming from my right (their left), instead of directly overhead. By asking the groom to turn his face toward the light, a nice shadow and highlight was created along his jawline.

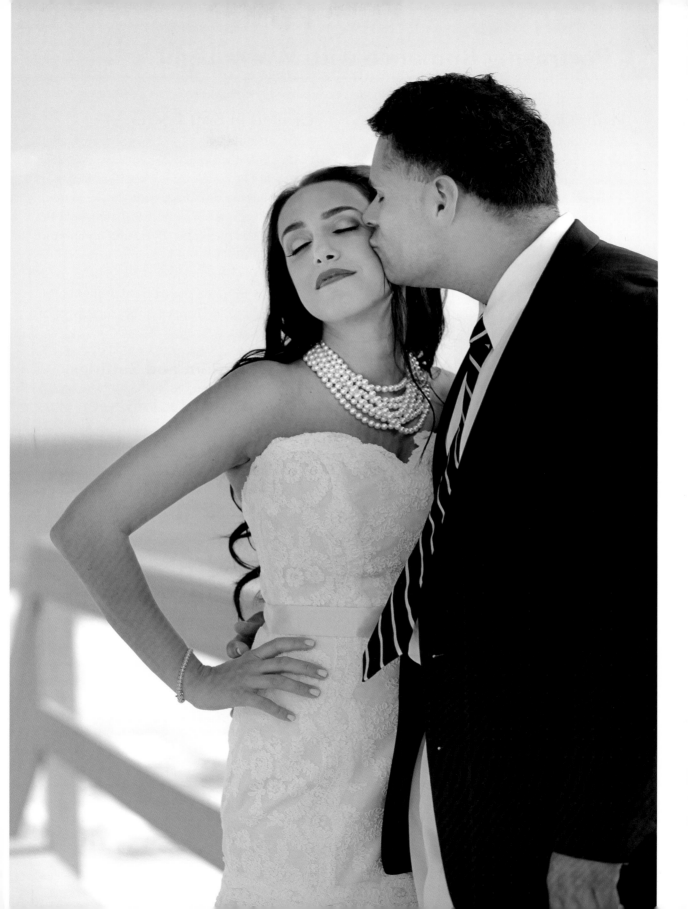

From *Okay* to *Wow*

My favorite time of day is about 20 minutes before sunset when the most gorgeous, warm, golden light appears. To me, warm light portrays romance; it takes a normal image from "okay" to "wow." Creating an image that has romance and a "wow" effect is something that I strive to accomplish at every wedding.

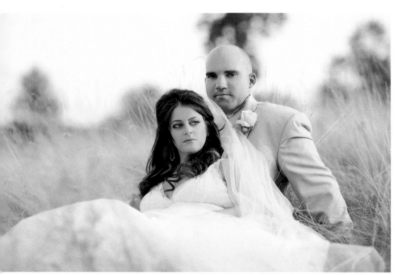

Circled in Soft Focus

Adjacent to the reception venue was a vibrant field of gold that I knew would be stunning for portraits. The couple agreed to sit in the grass, and by framing this image with "grass, couple, grass," it became apparent that there would be nice depth to the photo. By setting my aperture to f/2.2, I could keep my couple sharp, while the grass became soft. I asked them to turn away from the sun to avoid squinting eyes, which would happen if they looked toward the light.

Equipment and Settings

All three images in this series were photographed with a Canon 5D Mark II with a 135mm lens and the camera set at f/2.8 and ISO 200. The facing-page image was photographed at 1/800 second, and the images below were shot at 1/1000 second.

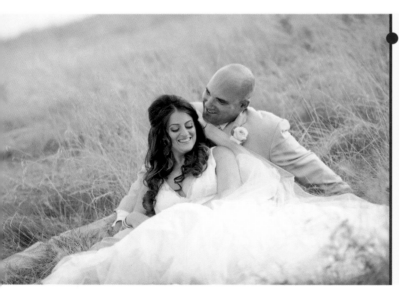

Photograph into the Sun: A Warm-Romantic Effect

I moved from my initial camera perspective because I wanted to capture the bride and groom's faces, yet still keep the sun out of their eyes. By photographing into the sun, I was able to get this beautiful warm light around the couple.

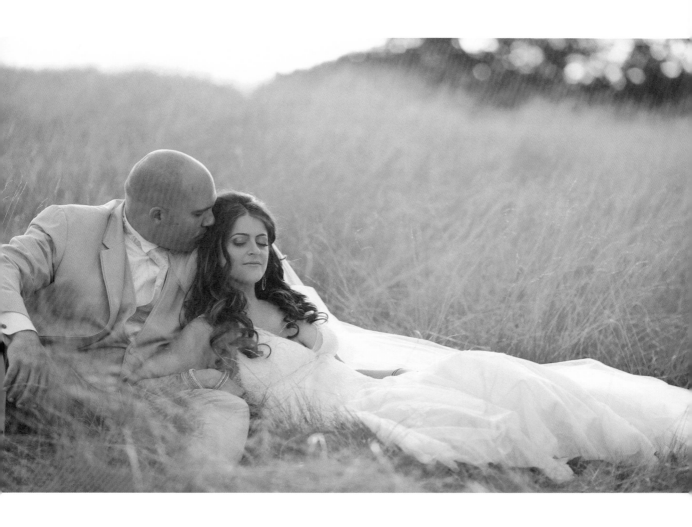

I asked them to turn away from the sun to avoid squinting eyes, which would happen if they looked toward the light.

Architecture and Light

I was excited about photographing this wedding in Southern California and I looked forward to checking out the venue before the event. When I am in a new location, not only do I tend to focus on architecture for composition, but I also focus a great deal on light; I like to see where I can creatively use natural light in a way so it does not appear flat.

Evaluating the Location

The location in front of the doors (below) was lined perfectly with potted plants, drawing the viewer's eyes directly to the couple. The walkway was also perfectly shaded from the bright California sun. Because the groom had custom sneakers made for the wedding day, I thought this pose could show them off in a natural way. After a few test images, I wanted the final portrait to be a little brighter, so I compensated my exposure to photograph +0.67 stop over the in-camera reading.

An Eye Open for Posing Spots

When I walked down one of the hallways at the reception location the day before the wedding, I noticed a piano that sat in an empty space lined with windows and doors (facing page). There was a wall directly behind the piano, which made the light a little more direct than if the space was wide open. I knew this would be a great spot to revisit on the wedding day. When it was time for portraits, I brought the bride and groom to this location. My thought was that it would be interesting to crop the image to focus on the groom, while keeping the bride in the image.

Equipment and Settings

All three images in this series were photographed with a Canon 5D Mark II with an 85mm lens. The facing-page image was photographed at f/1.6, $^1/_{1600}$ second, and ISO 1000. The two images to the left were photographed at f/2.8 with an ISO of 320. The upper was photographed at $^1/_{400}$ second and the lower was shot at $^1/_{500}$ second.

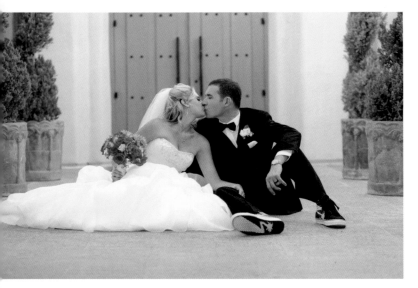

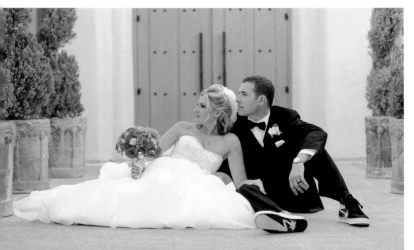

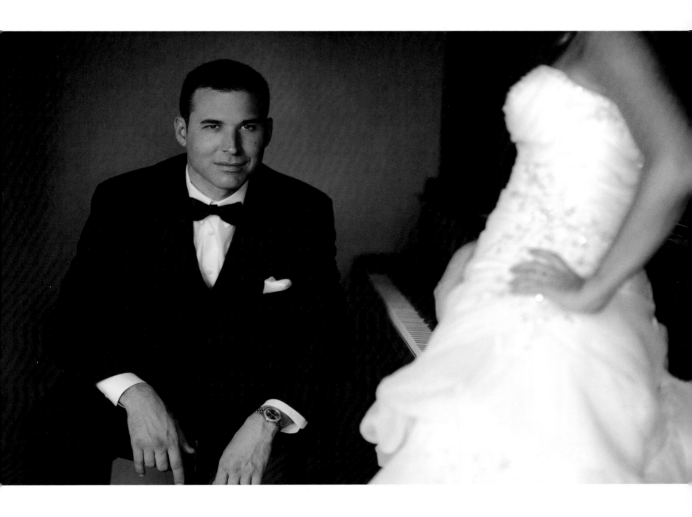

There was a wall directly behind the piano, which made the light a little more direct than if the space was wide open. I knew this would be a great spot to revisit on the wedding day.

Search for Better Light

I normally meet with the bride and the bridesmaids on the day of the wedding at the hotel where they are getting all glammed up for the big day. Hotel lighting can be very tricky because, typically, there is a lack of natural window light. In most instances, I have to set my white balance to reflect the type of bulb used in the hotel lights, and it is not always flattering. Because I try to stay away from flash as much as possible, I suggested to the bride that we should move to a meeting room where there were large windows, giving me a lot of natural light. She agreed, and this was the basis of creating this image. With the overhead lights turned off in the meeting room, the framed painting hanging on the wall reflected the bride as she stood near the window. I moved as close to the wall as possible to make sure that I could see her reflection as she stood in front of the window. I compensated by shooting at +0.33 stop over the ambient light to ensure that her reflection was bright in the image. By asking her to look down, we were able to create this very graceful pose.

Equipment and Settings

All three images in this series were photographed with a Canon 5D Mark II with a 50mm lens. The image to the left was photographed at f/2.2, $^1/_{100}$ second, and ISO 640. The images on the facing page were photographed at f/2.5, with an ISO of 1250. The upper was photographed at $^1/_{200}$ second, the lower left was photographed at $^1/_{1250}$ second.

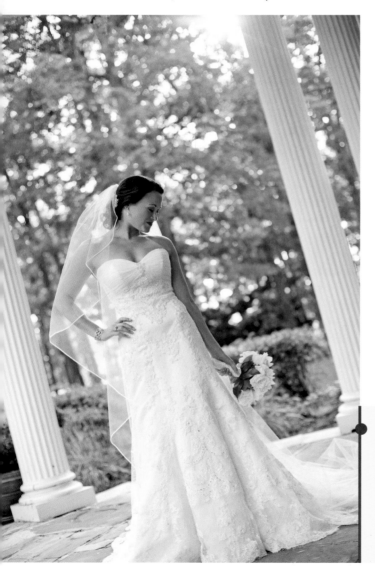

Photographing into the Sun for a Halo Effect

I moved from my initial camera perspective because I wanted to capture the bride and groom's faces, yet still keep the sun out of their eyes. By photographing into the sun, I was able to get this beautiful halo of light around the bride's head.

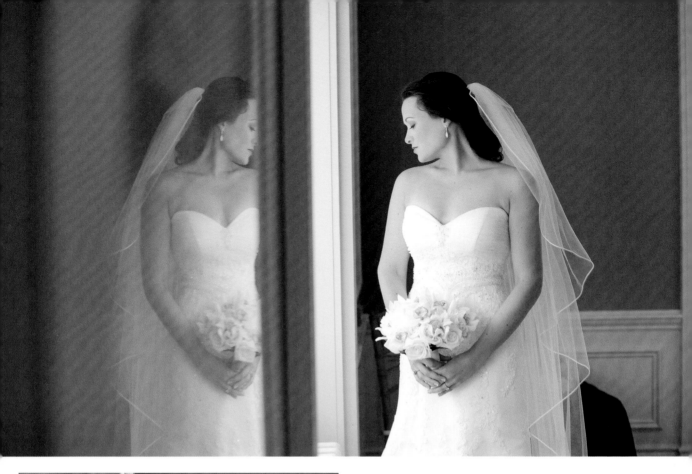

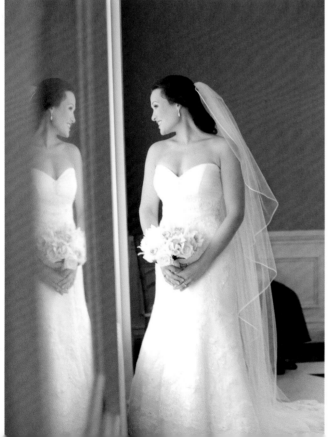

I suggested to the bride that we should move to a meeting room where there were large windows.

Push the Envelope

I knew this wedding was going to be edgy in style, and I was thrilled that I could push the envelope a little with posing and expressions. I notice right away when a bride and groom can pull off the "serious" look (both individually and together), and make it look amazing.

I used exposure compensation to photograph -0.67 stop under the recommended exposure.

Exposure Compensation on a Bright, Sunny Day

There was a small patch of light on the grass (below, left) that I knew would look great highlighting the bride's birdcage veil. When they sat down in the grass, I asked them to look off in different directions and to focus on something in the distance, thus creating a serious look. I set my ISO on the lowest setting and set my camera at f/2.5, which would ensure the treeline would be out of focus. However, because these settings let in too much light, I used exposure compensation to photograph -0.67 stop under the recommended exposure. I continued to photograph with the same settings in the same location, but switched up the poses, showcasing the groom (facing page) and the bride (below).

Equipment and Settings

All three images in this series were photographed with a Canon 5D Mark II with an 85mm lens. My camera was set at f/2.5 with an ISO of 100. The lower-left image was photographed at $1/640$ second, the image below was shot at $1/400$ second, and the facing-page image at $1/1000$ second.

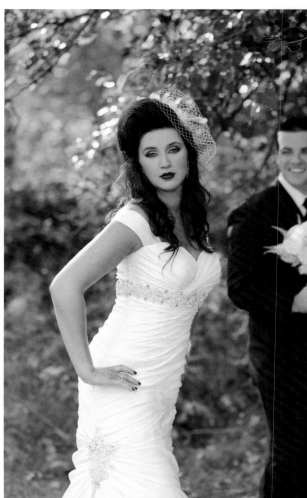

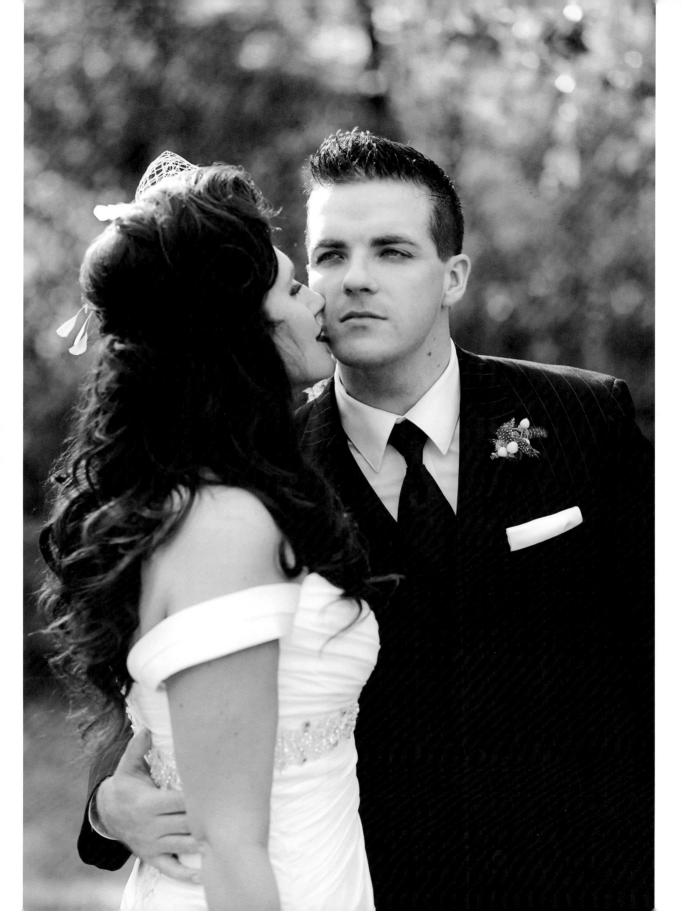

Autumn Color

Maine in the fall is absolutely stunning. During our initial consultation, I learned that the bride is a wedding photographer, which was very helpful, considering that I was traveling to a new location and she knew all the great locations where we could go for portraits. The ceremony was outside

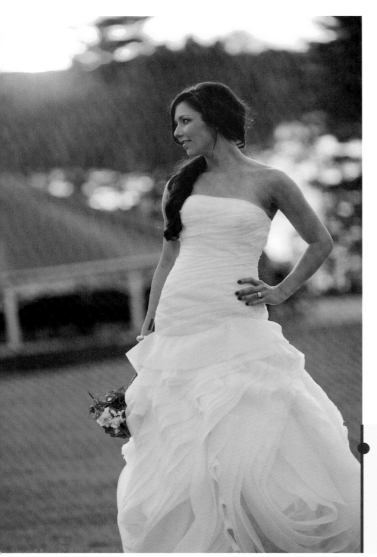

overlooking a valley that was filled with color from the changing leaves.

Softening the Light with a Diffuser

The light was incredibly bright, even though it was late in the afternoon. I knew that I would have to use my diffuser in order to soften the light and keep the detail in her dress. I love country images that are captured in an open field. I am not sure why I am drawn to it, but perhaps it is the contrast between the casual setting and the formal attire.

I knew that I wanted the bride and groom sitting down for some of their portraits; the couple was nicely framed with the valley of trees behind them, and the grass in the foreground highlighted just the right spots. When they locked their hands together and he kissed his bride's head, I knew I had my premier image.

Equipment and Settings

All three images in this series were photographed with a Canon 5D Mark II with a 135mm lens. The left image was photographed at f/2.5, $^1/_{1250}$ second, and ISO 1600. The images on the facing page were photographed at f/2.8 with an ISO of 160. The upper image was photographed at $^1/_{800}$ second and the lower-left image was shot at $^1/_{500}$ second.

The Waiting Bride

We had time for a few sunset photographs after we arrived at the reception venue. As we waited for the groom, the bride stood perfectly with the sun behind her. I asked her to place her hand on her hip and was able to get this beautiful image.

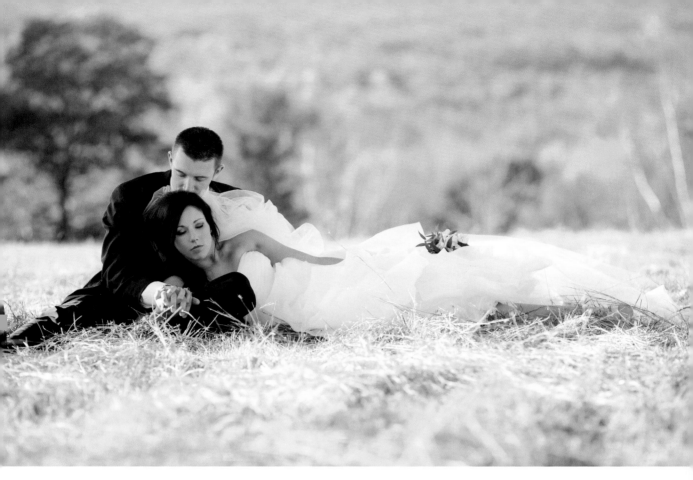

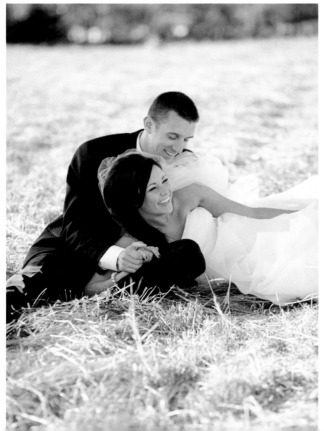

I knew that I would have to use my diffuser in order to soften the light and keep the detail in her dress.

The Reception Venue

As I pulled up to this reception venue at Hunter Mountain, located in the northern Catskill Mountains in New York, I saw this vibrant orange tree with a long wooden fence. It was such a stunning location, and I knew I could use the fence to create a leading line toward my subjects

Arranging Color and Pose

I pulled the couple to the sidewalk adjacent to the orange-leaf tree so that more of the surroundings would be visible. As the bride leaned back into the groom, I asked him to put his hand on her arm so that it appears as if he was pulling her in close.

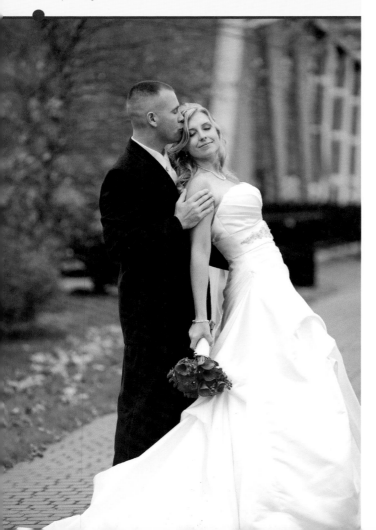

during the portrait session. It was a long walk from the ceremony to this location; fortunately, the bride and groom had hired a horse and carriage to take them around to each photographic location. This was our first stop; I did not want to risk losing the light because the sun was setting pretty quickly. I asked the groom to sit on the fence (facing page) so that the bride could come in nice and close. By framing the shot with the fence to the left side of the photograph, a leading line was created to draw the eyes to the bride and groom. I also found it very appealing that there were orange leaves on the ground and above them, creating a natural frame around the couple.

Equipment and Settings

All three images in this series were photographed with a Canon 5D Mark II with a 135mm lens. Each image was shot at f/2.5 and ISO 500. The facing-page image was photographed at $1/500$ second; the images below were photographed at $1/640$ second.

It was a long walk from the ceremony to this location; fortunately, the bride and groom had hired a horse and carriage . . .

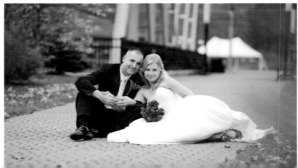

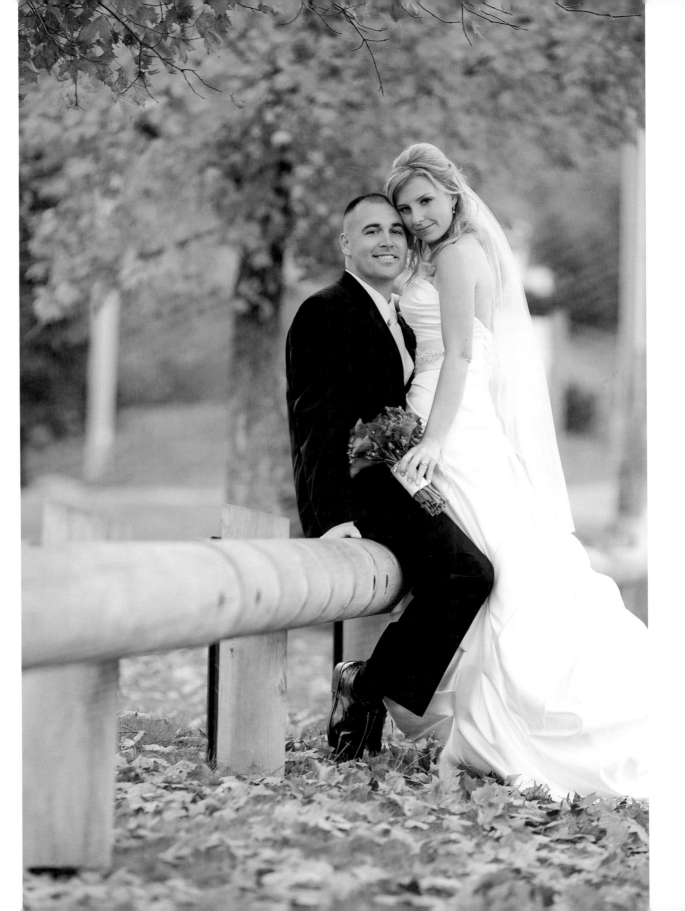

Winter Weddings

Winter weddings can be challenging because the sun sets so early, and unless you schedule portraits before the ceremony, chances are any images that you take will be in the dark. This wedding location was great because they had a lit walkway, and the grounds were decorated for the holidays with white lights in the surrounding trees.

As we arrived at the reception venue, I began to think of poses that would look nice with the lights behind the couple. Because it was so cold, I wanted them to snuggle up into each other—having their foreheads touch demonstrates a level of connectedness between them. Even though the path was lit, I still needed to use flash as a fill. By photographing at +.33 stop over the ambient light reading and dragging the shutter, I was able to create a portrait of this very romantic moment.

Equipment and Settings

Both images in this series were photographed with a Canon 5D Mark II with an 85mm lens. The camera was set at f/2.5, 1/40 second, and ISO 1000.

Capturing a Sweet Moment

Using the same camera settings, as the groom lifted his bride, I was able to capture this sweet moment.

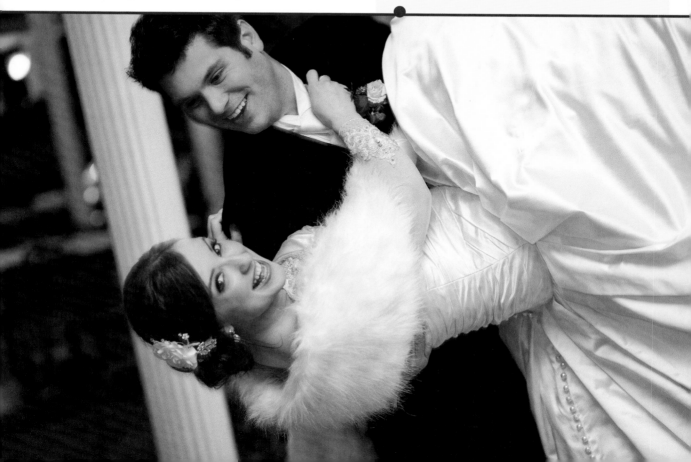

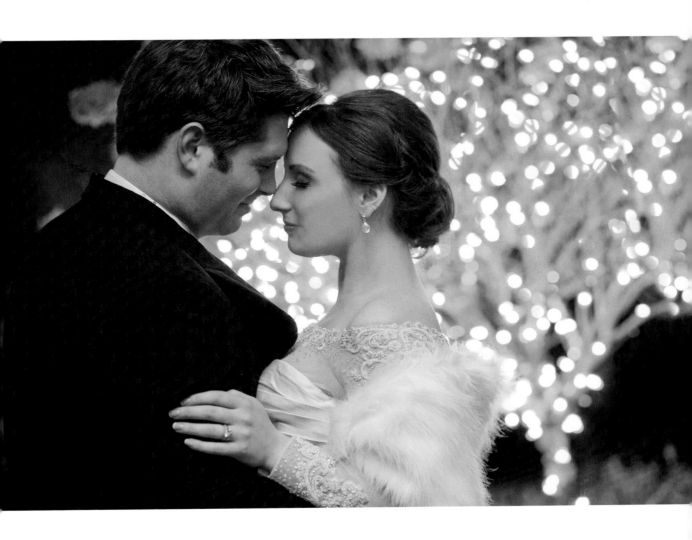

I wanted them to snuggle up into each other—having their foreheads touch demonstrates a level of connectedness between them.

The Golden Hues of Sunset

April weddings can be a big gamble in terms of the weather, especially in upstate New York. With this late April wedding, I was thrilled that the forecast was in our favor. The Hall of Springs in Saratoga, New York, has so many beautiful locations for photos, and one of the most popular is near the reflection pool. During sunset, the golden light shines on the surrounding architecture and is then reflected with the same warmth in the water. This couple was filled with so much love and happiness. I wanted to showcase their personalities and the love they share by asking them to dance! By placing them near the pool, I knew that I would be able to capture the reflection mirrored in the water.

Equipment and Settings

All three images in this series were photographed with a Canon 5D Mark II with a 135mm lens. My camera was set at f/2.5 and ISO 800. The upper facing-page image was photographed at $1/800$ second. The lower facing-page image was shot at $1/640$ second. The left image was photographed at $1/400$ second.

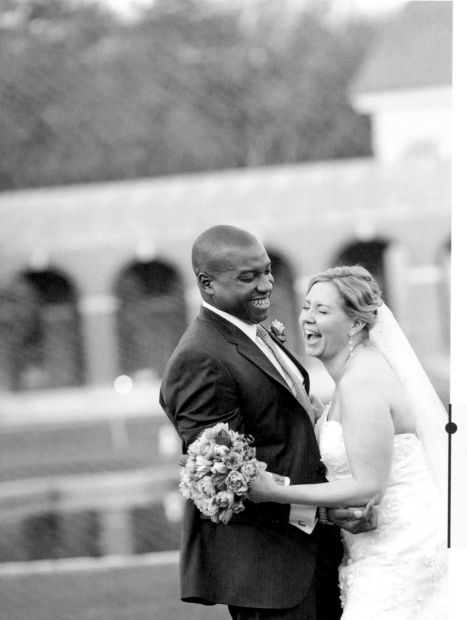

Candid Moments

With the same aperture and ISO settings I continued to capture some amazing candid moments between the bride and groom as they shared a dance in the open field.

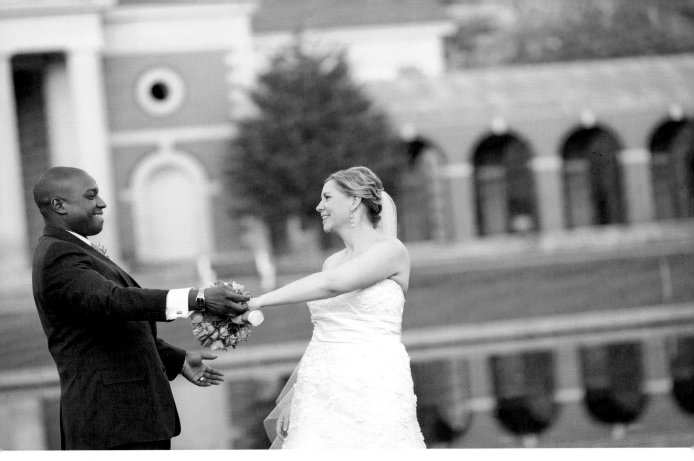

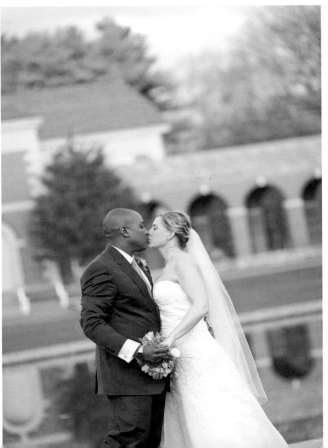

*I wanted to showcase
their personalities and
the love they share by
asking them to dance!*

Incorporating Foreground Objects

I love photographing through things to create a sense of dimension. Whether it is a door, an element of nature, or even another person, creating greater depth by photographing wide open creates a much more interesting composition. Here, using a shallow depth of field heightened the effect.

We had scheduled the *first look,* as well as other portraits, prior to the ceremony, and I was not sure what to expect. I arrived early to scope out some good locations, of which there were many. I was immediately drawn to this colorful cherry tree located in front of the venue. After the *first look* was photographed, I positioned my couple on one side of the tree, photographing through the branches to show off the color of the tree, while keeping the focus on the bride and groom.

Equipment and Settings

All four images in this series were photographed with a Canon 5D Mark II. The upper and lower-left images on the facing page were photographed with a 135mm lens and exposed at f/2.5, and ISO 160. The upper image on the facing page was photographed at $1/400$ second, and the lower-left facing image at $1/320$ second. The lower-right facing-page image was photographed with a 135mm lens at f/2.5, $1/640$ second and an ISO of 400. The image below was photographed with an 85mm lens. The exposure was f/2.8, $1/250$ second and ISO 320.

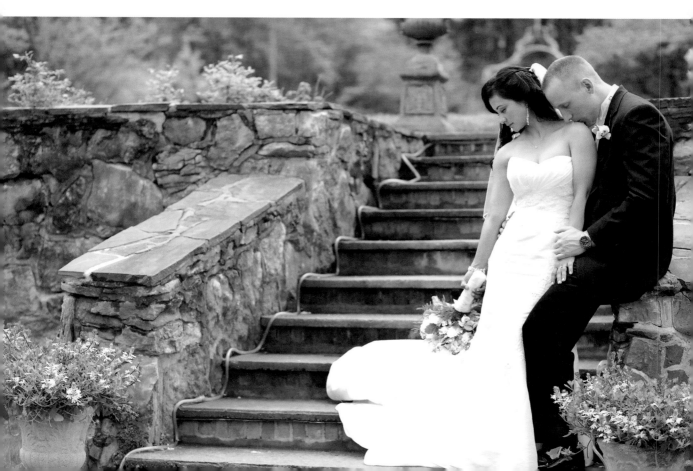

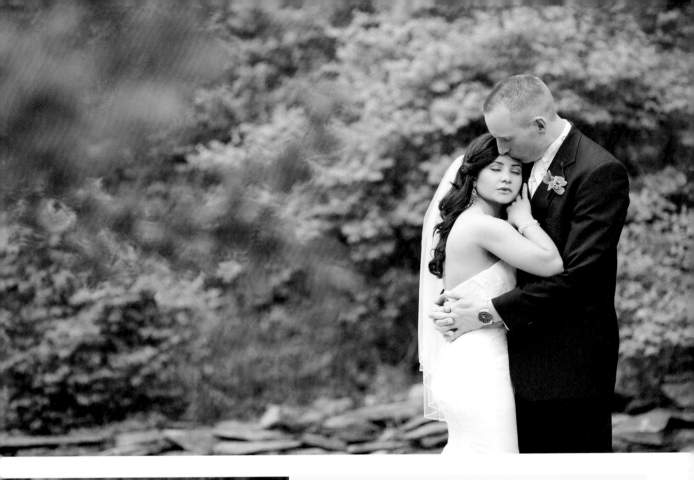

Offer a Playful Image

For this image, I pulled the bride in front of the groom for a more playful look. By turning her shoulders to the side, and placing her hand on her hip, the beautiful form of her dress was emphasized.

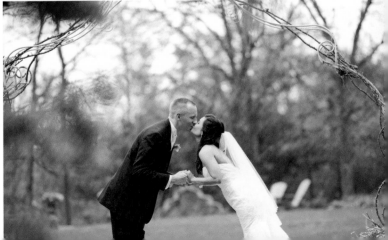

Location

This wedding took place in Lake George, NY, and even though rain was predicted, I had only positive thoughts for good weather.

Window Light

Window light is a powerful thing; it can bring the simplest pose to life. The photograph on the facing page was made after the bride finished getting ready, and moments before she saw her father for the first time after she was in her gown. A wedding day is about the bride and the groom, but really the majority of the focus is on the bride. I wanted to focus on the beautiful young woman who was about to marry the man of her dreams.

There was a chair in a small room just off the suite where she got dressed. I asked her to sit with her arm resting on the seat cushion. By turning her face toward the window, the light spilled across her body, creating beautiful highlights and shadows.

Equipment and Settings

All three images in this series were photographed with a Canon 5D Mark II with an 85mm lens. The image on the facing page and the image below were photographed at f/2.8 and ISO 1250. The facing-page image was photographed at $1/1250$ second, and the image below was shot at $1/500$ second. The image on the left was photographed at f/2.5, $1/1600$ second, and ISO 125.

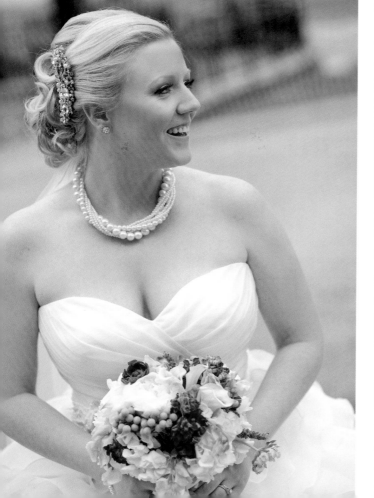

Always Create an Alternative Image

For an alternative image in the same setting, I asked the bride to turn away from the light. This created a nice separation highlight between the wall and the bride.

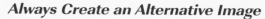

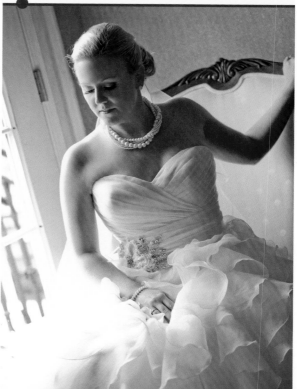

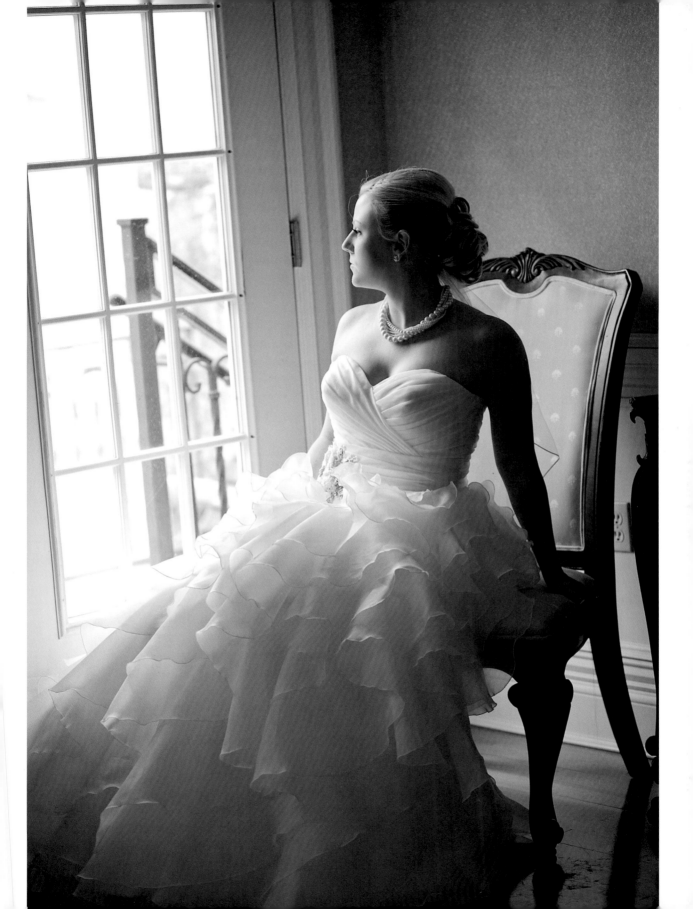

Set the Stage with Props

A Personal Touch

Being in front of the camera can make people feel uncomfortable, but working with props can help ease most jitters. Here, I used a Rolls Royce as a prop. The groom had a pair of sunglasses that I felt would be a nice addition to the photograph. I asked the groom to put his foot on the bumper of the car and hold on to his sunglasses, creating a very masculine stance. This image is reminiscent of something one might see in the 1960s–a man with his car and the love of his life!

Adjusting the Exposure

After one test image, I realized that I wanted the bride and groom to appear a little brighter. By compensating +0.67 over the test exposure, I was

The groom had a pair of sunglasses that I felt would be a nice addition to the photograph.

able to create the exposure I was going for without blowing out any detail in the bride's gown.

Equipment and Settings

All three images in this series were photographed with a Canon 5D Mark II. The image below and lower-facing-page image were photographed with a 50mm lens at f/2.5 and ISO 250. The lower-facing image was photographed at $1/400$ second, and the image above was shot at $1/800$ second. The upper-facing-page image was photographed with a 135mm lens. The exposure was f/2.5, $1/800$ second, and ISO 100.

Working in a Tight Space

I was photographing with my 50mm lens because I was in a very tight space and I wanted to ensure that I could see part of the car. We were under a covered walkway and only had minutes to capture these images; the light shade under the covered walkway ensured the couple was perfectly lit.

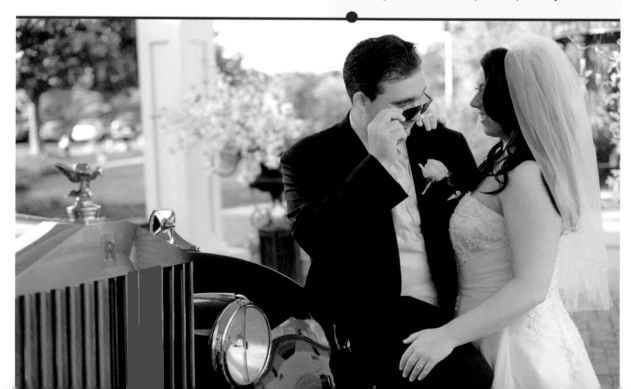

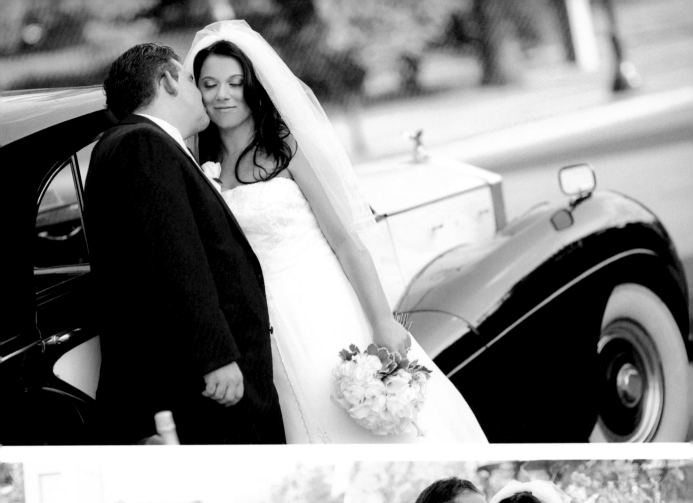
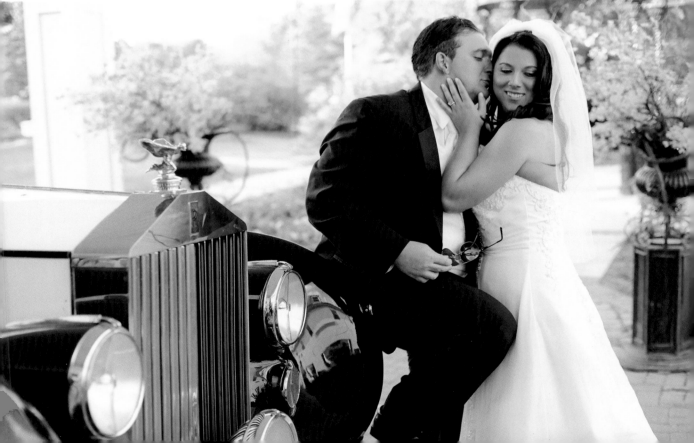

Get Input from Your Clients

I always encourage my clients to provide a list of desired images. Even though I have my own

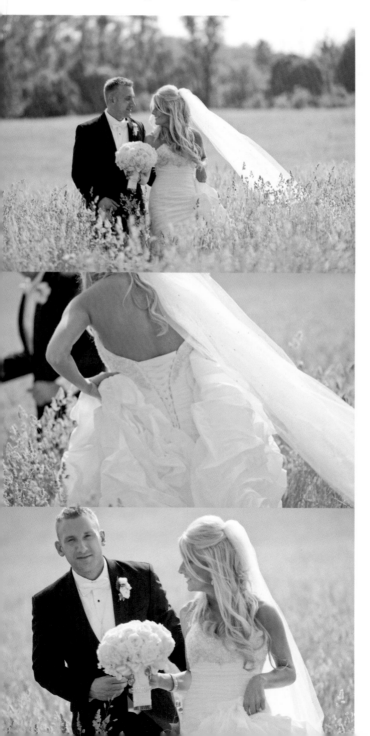

checklist that I routinely go through, it helps me to know what my clients would like and what they expect. We started early in the day for this June wedding because the bride and groom chose to complete all photos before the ceremony.

Finding a Location in Advance

I knew that finding a large open field was important to this couple, so after the *first look* photographs, we drove around the local area to find the perfect location. On most wedding days, the bride, groom, and I do not have the luxury of scouting a location to photograph because we are on a very tight schedule. For this wedding, we planned ahead and were able to find the perfect location. We pulled off to the side of a country road and I hopped into the back seat of my car in order to photograph in the shade; the sun was extremely bright and I did not want lens flare for this image. It worked out perfectly; it was still very bright outside and I compensated by shooting at -0.67 stop under the metered exposure.

Finding a large open field was important to this couple . . .

Equipment and Settings

All six images in this series were photographed with a Canon 5D Mark II. All these field images were photographed with a 135mm lens and the camera was set at f/2.5 and ISO 100. Both top-facing-page and middle-left images were photographed at $^1/_{4000}$ second. The upper-left, lower-left and lower-left-facing-page images were shot at $^1/_{3200}$ second. The lower-right-facing-page image was photographed at $^1/_{2000}$ second.

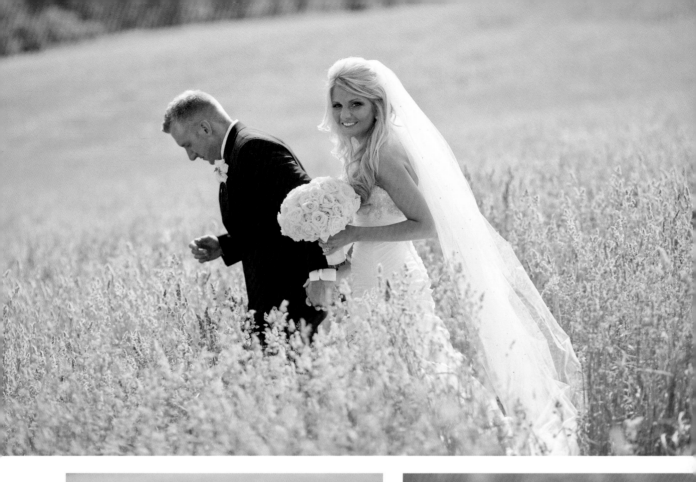

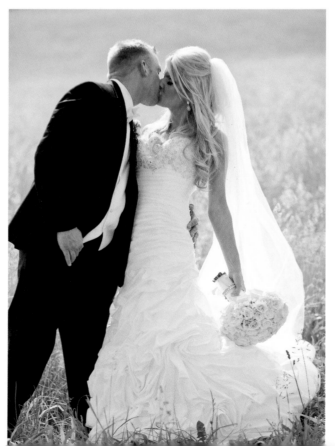

Urban Setting

I like using the environment around me to create appealing compositions. For this session, I was in an urban setting that included an iron fence. Sometimes it takes me a few moments before I recognize the image that I want; I often laugh at myself because I find myself circling the couple until I find the perfect angle.

As I stated in an earlier description, using my surroundings to photograph through something such as leaves or fences can help add dimension to an image. I asked my couple to stand on the sidewalk as I walked to the other side of the fence. The iron rods separated them in a very interesting way; I liked how the rods in the fence divided the image so that the viewer is able to focus on each individual. By photographing at f/2.5, I was able to blur the fence just enough so that the attention is not lost from the main subjects, the bride and groom.

I wanted to pose the groom in a way that did not appear to be posed, as if he was just talking with the groomsmen, off camera, as the bride looked back lovingly over her shoulder at her husband.

Equipment and Settings

All three images in this series were photographed with a Canon 5D Mark II with an 85mm lens. My camera was set to f/2.5 and ISO 160. The upper-facing-page image was photographed at $1/640$ second. The lower-facing image was shot at $1/1600$ second, and the image below was photographed at $1/500$ second.

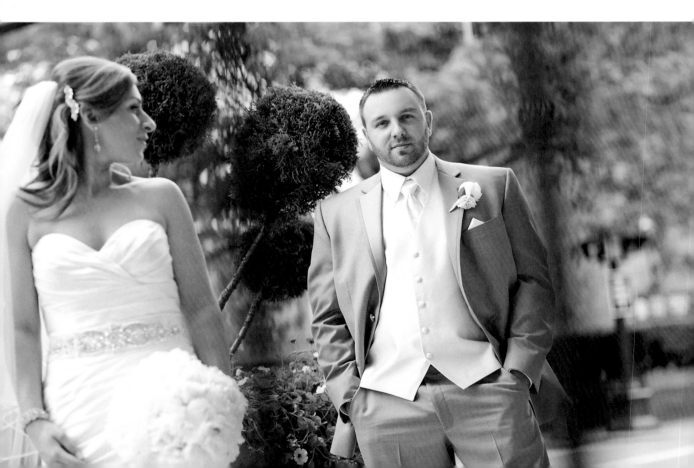

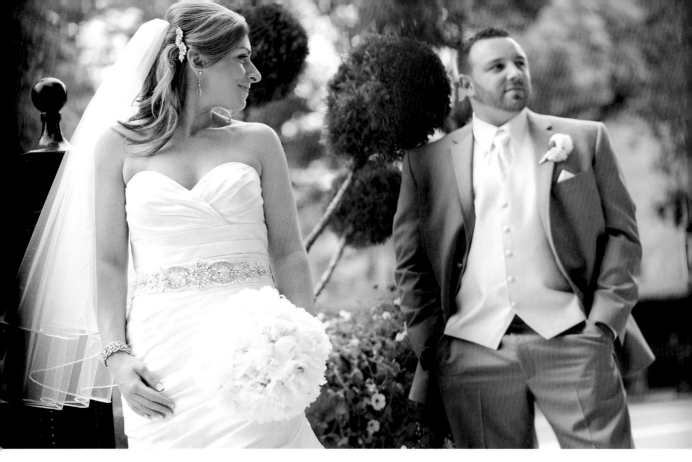

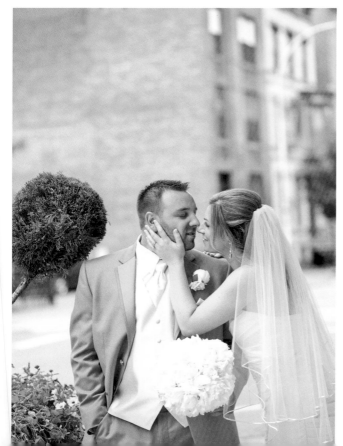

Using my surroundings to photograph through something such as leaves or fences can help add dimension to an image.

Rainy Weather

This April wedding posed some challenges because of the weather. We had small windows of time to photograph outside because the rain would come and go. When the rain let up, I grabbed the bride and groom and headed down

We had small windows of time to photograph outside because the rain would come and go.

to the water. The wedding was held in Poughkeepsie, and it was my first time photographing at this location. The bride and groom had told me that there was an "awesome" bridge behind the reception venue. I knew that I wanted to create some images of them with the bridge in the background. The lines of the bridge and the sidewalk helped to frame the bride and groom as they walked along the water. Following the bridge line to the right of the image, the viewer will notice that the sidewalk and rocks meet, almost to a point. This helps draw the viewer's eyes to the bride and groom. Because the setting was so beautiful, I wanted a simple pose of them holding hands and walking toward me.

Equipment and Settings

Both images were photographed with a Canon 5D Mark II with an 85mm lens. I shot at f/2.5 and ISO 800. The image on the facing page was photographed at $^1/_{100}$ second, and the image below was photographed at $^1/_{160}$ second.

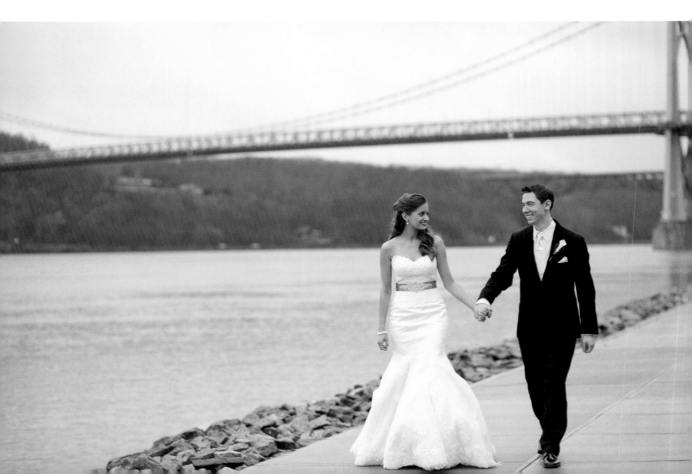

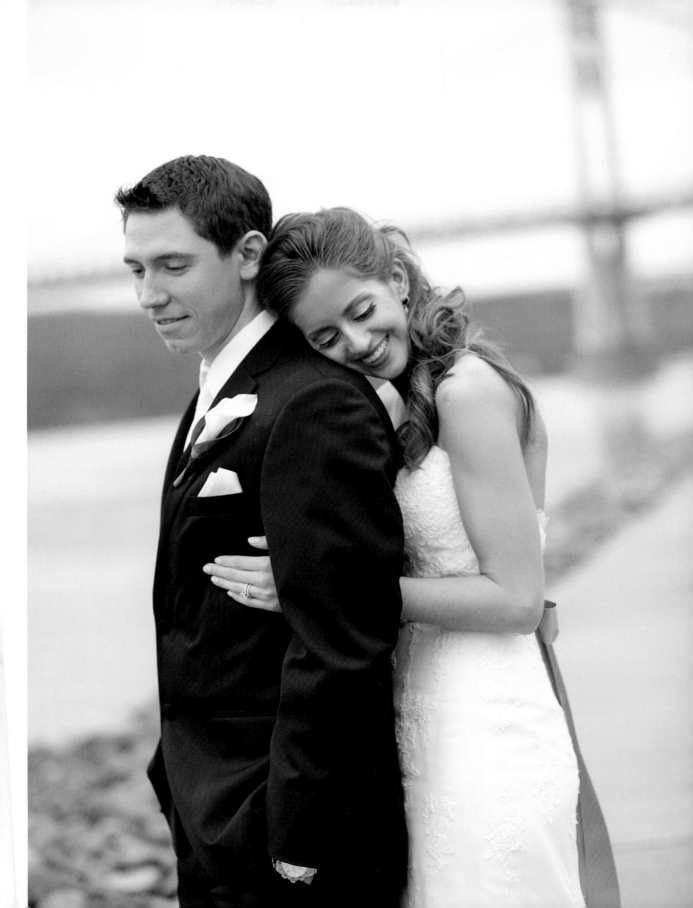

Sunset with a Golden Glow

For this summer wedding, my assistant and I spent the majority of the afternoon at this venue in Troy, NY, taking portraits of the bride, groom, bridal party, and family members. Toward the end of the cocktail hour, after I had photographed in the room where the reception was taking place, I reached out to my couple to see if they were interested in some beautiful sunset portraits on the rooftop of this building, and they enthusiastically agreed! Once on the roof, the sun was in a perfect position. I wanted to show the golden glow behind them, so I positioned them next to the sun. I asked the groom to sit down and I had the bride stand because I thought it would be nice to see her entire dress.

I think this pose is modern, yet still romantic, because she softly places her hand on his neck.

Equipment and Settings

All three images in this series were photographed with a Canon 5D Mark II. My camera was set to f/2.5 and ISO 500. The image below was photographed with an 85mm lens at $\frac{1}{2000}$ second. The facing-page images were photographed with a 135mm lens, $\frac{1}{640}$ second (upper image) and $\frac{1}{800}$ second (lower-right image).

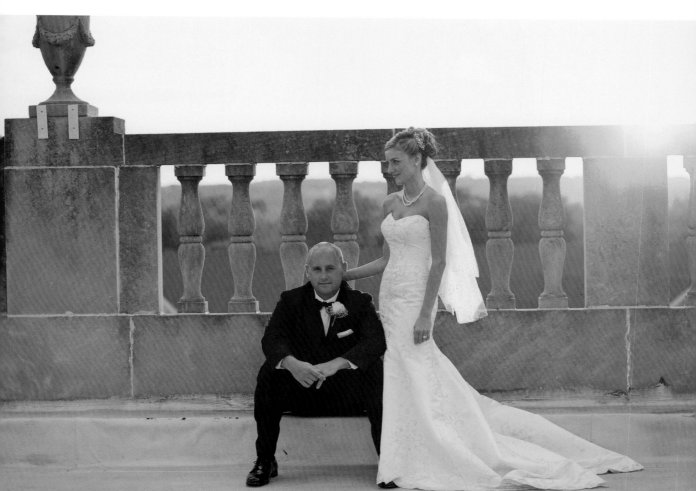

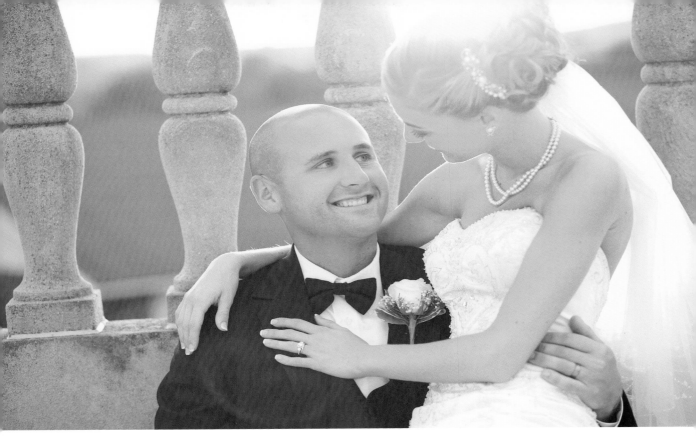

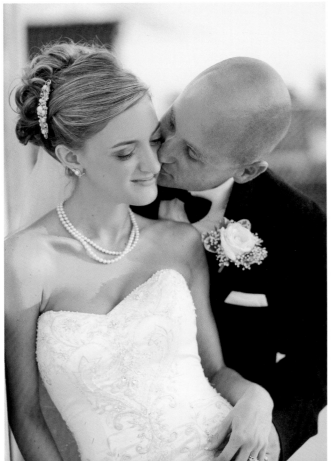

I wanted to show the golden glow behind them, so I positioned them next to the sun.

Networking

I take advantage of every opportunity to work with wedding vendors; it is a great way to practice posing and experiment with different lighting. It is important to me, when working with other vendors, that I showcase their product. In this session, I wanted to focus on the bride and her makeup and fashionable headpiece. By switching up the angle in the image to the right, this can easily be used by the makeup artist for marketing. In the images on the right and the photograph on the facing page, the headpiece stands out making a bold and beautiful statement. An image like this and also could be used by the dressmaker.

Different Styles

The session took place in mid-May at an apple orchard when the trees were in peak blossom and created a soft, romantic backdrop for the edgy, beautiful bride. Not every bride is traditional, so being able to showcase different styles can help attract more clients. I like how you can see the bride and groom in a gorgeous, lush spring setting in the image to the right. Photographing at f/2.5 allowed me to really focus on the bride and groom, yet still show some of the environment. I wanted the surrounding table and trees to be nice and soft so that these elements did not compete with the couple.

Equipment and Settings

All three images were photographed with a Canon 5D Mark II at f/2.5, with an ISO of 200, and an 85mm lens. The lower-right and facing-page images were photographed at $1/2000$ second, while the bottom-left image was shot at $1/1000$ second.

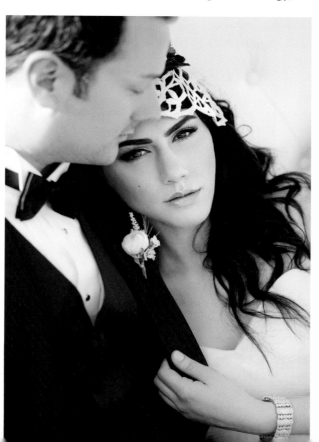

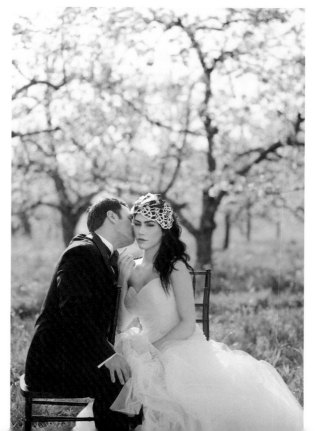

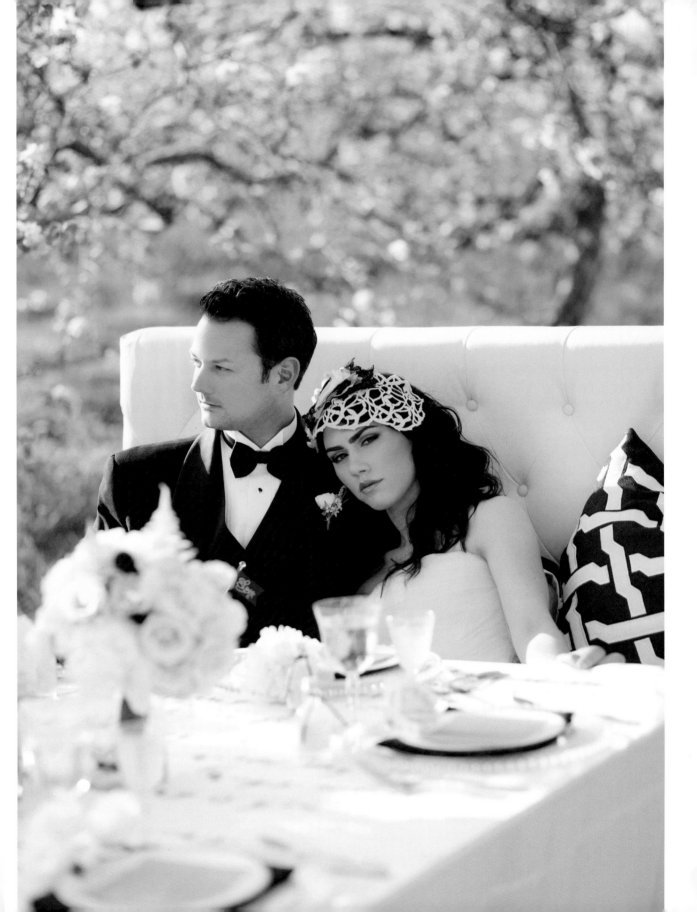

Index

OTHER BOOKS FROM
Amherst Media®

The Beckstead Wedding

Industry fave David Beckstead provides stunning images and targeted tips to show you how to create images that move clients and viewers. *$27.95 list, 7.5x10, 128p, 200 color images, order no. 2045.*

Dream Weddings

Celebrated wedding photographer Neal Urban shows you how to capture more powerful and dramatic images at every phase of the wedding photography process. *$27.95 list, 7.5x10, 128p, 190 color images, order no. 1996.*

One Wedding

Brett Florens takes you, hour by hour, through the photography process for one entire wedding—from the engagement portraits, to the reception, and beyond! *$27.95 list, 7.5x10, 128p, 375 color images, order no. 2015.*

The Beautiful Wedding

Tracy Dorr guides you through the process of photographing the authentic moments and emotions that make every wedding beautiful. *$27.95 list, 7.5x10, 128p, 180 color images, order no. 2020.*

Modern Bridal Photography Techniques

Get a behind-the-scenes look at some of Brett Florens' most prized images—from conceptualization to creation. *$29.95 list, 7.5x10, 160p, 200 color images, 25 diagrams, order no. 1987.*

500 Poses for Photographing Groups

Michelle Perkins provides an impressive collection of images that will inspire you to design polished, professional portraits. *$34.95 list, 8.5x11, 128p, 500 color images, order no. 1980.*

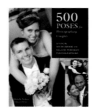

500 Poses for Photographing Couples

Michelle Perkins showcases an array of poses that will give you the creative boost you need to create an evocative, meaningful portrait. *$34.95 list, 8.5x11, 128p, 500 color images, order no. 1943.*

BRETT FLORENS' Guide to Photographing Weddings

Learn the artistic and business strategies Florens uses to remain at the top of his field. *$19.95 list, 8.5x11, 128p, 250 color images, index, order no. 1926.*

500 Poses for Photographing Brides

Michelle Perkins showcases an array of head-and-shoulders, three-quarter, full-length, and seated and standing poses. *$34.95 list, 8.5x11, 128p, 500 color images, index, order no. 1909.*